The Complete Book of 35mm Photography

The Complete Book of
35 MM
Photography

by
Jerry Yulsman

ROBERT HALE · LONDON

Copyright © 1976 by Jerry Yulsman
First published in Great Britain 1979

ISBN 0 7091 7347 4

Robert Hale Limited
Clerkenwell House
Clerkenwell Green
London EC1R 0HT

Printed in Great Britain by
Lowe & Brydone Printers Limited, Thetford, Norfolk.
Bound by Weatherby Woolnough Limited, Northants.

In memory of two friends who knew the magic—
EDDIE FEINGERSH
PAUL SHUTZER

And thanks to BILL BROECKER, JOHN JOHNY,
and the twins at Advance Camera

TABLE OF CONTENTS

INTRODUCTION 13

PART ONE—The Tools 17

Chapter One—The Camera 19
 The Focusing Mechanism 22
 The Iris Diaphragm 25
 The Shutter 28
 The Viewfinder 29
 Film Transport 31

Chapter Two—Camera Features 32
 Lens Interchangeability 32
 The Automatic Diaphragm 33
 The Built-in Exposure Meter 34
 Flash Synchronization 35
 The Removable Pentaprism 37
 The Viewfinder Readout 37
 The Self-Timer 41

Chapter Three—The Automatic Camera 42
 Shutter Preferred and Aperture Preferred Autocameras 45
 Shutter Preferred 45
 Aperture Preferred 45

Chapter Four—Lenses 47
 Aperture (*f*/Stop or "Speed") 47
 Focal Length 47
 The Telephoto Lens 51
 The Wide-Angle Lens 53
 The Zoom Lens 55

Chapter Five—The Evolution of Photographic Film 59

Chapter Six—Film Function 66
 Film Speed (Black and White and Color) 66
 Grain (Black and White and Color) 67
 Acutance and Sharpness (Black and White and Color) 70
 Contrast (Black and White and Color) 70
 Color Saturation (Color Film) 71
 Maximum Density ("D-Max") (Color) 71
 Tungsten Film (Color Transparency) 73
 Negative Color Film 74
 Reciprocity Failure (Black and White and Color) 75
 Film Care 75
 Some General Rules to Follow 76

Chapter Seven—The Exposure Meter 78
 Photoelectric Cells 78
 The Selenium Cell 78
 Cadmium Sulfide Cell (CDS) 79
 Silicon Blue Cell 80
 Exposure Meter Scales 80
 Reflected-Light Meters 81
 The Incident-Light Meter 85
 The Spot Meter 87

PART TWO—Camera Techniques 89

Chapter Eight—Focusing 91
 Focusing Aids 92
 Split-Image Spot 92

Microprism Circle (or Collar) 93
Coarse-Ground-Glass Circle (or Collar) 93
Infinity (∞) 94
Action Focusing 95

Chapter Nine—Depth of Field 97
Selective Focus 100
Front Focusing 103
Deep Focus 103
Depth-of-Field Scales 105
Image Size and Depth of Field 106

Chapter Ten—Exposure. 110
Underexposure 111
Overexposure 112

Chapter Eleven—Exposure Control 114
The Use of the Built-in (BTL) Camera Meter 114
The Use of the Incident-Light Meter 119
Normal Use in Relatively Uncontrasty (Flat) Light
(Color and Black and White) 120
Contrasty Light (Color) 120
Contrasty Light (Black and White) 121
Bracketing 121
"Creative" Underexposure (Color Transparency) 122
Flesh Tones 122

Chapter Twelve—Perspective 126
Wide-Angle Distortion 129

PART THREE—Light 133

Chapter Thirteen—Light and Color Theory 135
Color Temperature 135
Additive and Subtractive Color 136

Chapter Fourteen—Shooting in Daylight 141

Chapter Fifteen—Shooting in Incandescent Light 146
 Types of Light Bulbs 147
 Light Stands 150
 Conventional Lighting 150
 Bounce Light 152
 Umbrella Light 153
 Electrical Power 154

Chapter Sixteen—Shooting in Low Light 155
 Available-Light Photography 155
 "Pushing" 157
 Tripods 159
 Mirror Lockup and Cable Releases 160
 Bracing the Camera 161

Chapter Seventeen—Filters 165
 Conversion Filters, 85 #(85A) and 85B 165
 Haze and Skylight Filters 166
 Neutral-Density Filters 166
 Polarizers 166
 Star Filters 166
 Fog Filters 167
 Color-Compensation Filters 169
 Soft-Focus or Diffusing Filters 170
 Fluorescent Filters 170

Chapter Eighteen—Electronic Flash 173
 The Capacitor 173
 Recycling Time 173
 Power Sources 174
 Alkaline Cells 174
 Nickel-Cadmium Cells 174
 High-Voltage Batteries 175
 Output 176
 Flash Exposure Calculation 177
 Guide Numbers 177
 Key-Exposure System 179

Exposure Calculator 181
Strobe Meters 181
Autoflash 182
Bounce Flash 185
Umbrella Flash 187
Minimal Flash 188
Synchro Sunlight 189
Filters 190
Multiple Flash 190

GLOSSARY 193

A FEW WORDS ON EQUIPMENT BUYING 203

APPENDIX ONE—Suggested Systems 208

APPENDIX TWO—Reciprocity Tables 210

APPENDIX THREE—Tests for Exposure Meter Accuracy 212

APPENDIX FOUR—"Pushing," or Forced Processing 216

APPENDIX FIVE—Depth-of-Field Scales 219

Introduction

Photography has been a major part of my life for forty years. It started with a $13.50 Argus camera I received as a twelfth birthday present from a favorite aunt. Times were bad, it was the Depression years, but somehow there was a feeling of upward mobility. In Philly, things were as bad as they were going to get—there was an ambience of excitement and expectation. (At least it felt that way to us kids.)

The Argus changed my life. Of course, at that age everything changed my life—there were breakthroughs every three days: jazz, politics, girls . . . however, I never got very good with the bass fiddle, and politics was a mystery I still haven't solved, and in those days I was constantly putting my foot in my mouth as far as girls were concerned. *But I was a good photographer.* I understood both the language and the magic. It seemed to come naturally, like a gift from Providence. Film was cheap: 25¢ a roll, if I remember correctly, for "Standard" (blue-sensitive film). And it was a simple matter to save my school lunch money and give up Saturday matinees. I had a cheese box enlarger and four 8" x 10" trays and gobs of Dektol and D-76. I photographed landscapes and football games and took candids of my teachers and Chinatown and FDR as he passed in the middle of a torchlight parade on his way to the convention. (I would give anything to have that negative now.)

13

Later, I quit high school and eight or nine months before Pearl Harbor, I ran away, lied about my age, and joined the Air Corps. They told me at MacDill Field in Florida that I could choose whichever service school I wanted, so naturally I chose the photography school at Lowery Field in Denver. I got to Lowery, but not to photography school. The only camera I dealt with during my three months at armament school was a gun camera.

Later, overseas, I managed, with a battered Leica, to take pictures whenever the opportunity presented itself. I was irrevocably hooked, so it was New York and the big magazines and the foreign assignments and the Limelight Café in the Village— where we all got together to talk photography and laugh a lot and lie to each other about our exploits. Today, there are no Limelights. Today, it is the schools filled with *real* photography students that supply the fertile atmosphere for growth.

Photography, too, has changed. Most of the giant magazines are gone, but there are galleries and books and other things— a different kind of excitement. And it's still "the good old days." Photography is being taken more seriously than ever before. There are critics now and controversy, and a diversity of approach that was unthinkable even ten years ago.

My point of view is currently at odds with a good deal of the serious thinking. I believe that the main function of photography is a historical one. I think of photographs first as historical documents—delineating time and place, and only secondarily as possible works of art. My own personal photograper-heroes— W. Eugene Smith, Henri Cartier-Bresson, Erich Salomon, Robert Capa, Dorothea Lange, Diane Arbus, and others—have shown me what it's like. They deal with the real world, filtering it through their own consciousness and experience, interpreting reality and making it art. What a magnificent craft!

Photography has and still continues to give me joy and excitement. It takes me everywhere and shows me everything under

the sun. It's educated me . . . it is still educating me. I can only wish the same for all who read this book.

What follows is a kind of manual on the use of photographic tools. It is my contention that one can be *taught* the techniques of photography, but one has to *learn* the art of photography. The learning process involves an interest in the world and a desire to understand one's every experience. It involves also the development of a visual orientation—of being able to picture, in frozen slices of time, ideas, concepts and history. One must learn to live through one's eyes.

The purpose of this book is to present the reader with the basics of photographic technical know-how. His talents and personal vision are required to carry him forward from there. These can be aided and abetted by an interest in and exposure to all graphic media. The serious photographer should familiarize himself with the work of others—serious painters, filmmakers, graphic artists and designers, and of course other photographers. It is from them he will learn the basics of design, the uses of space and negative space, the meaning of color—and, if he is lucky, will be inspired and influenced. Such inspiration and influence are a good beginning toward developing his own personal vision, a way of seeing and producing pictures that is uniquely his.

I also advise him to acquire certain helpful publications such as the Kodax "Dataguides," available from most photo dealers—containing excellent technical charts and other data which are continually being updated. Two other good sources of information, published in loose-leaf form and periodically updated, are *The Photo-Lab-Index,* and *Current 35mm Practice,* published by Morgan & Morgan.

But first, here are some of the tools and techniques to help you break through into this marvelous world of photography. Good luck!

—Jerry Yulsman
New York

Part One

THE TOOLS

A photographer must learn to use his tools instinctively. This is particularly true of the photographer who depends on 35mm photographic equipment. The camera must be his third eye, a part of his physical being. He must never let it get between him and his subject matter, an inert piece of machinery that requires constant attention.

As the beginning photographer progresses, he finds that many situations call for a continuing series of technical decisions, calculations, judgments. He must respond to these necessities, using a small corner of his mind, while the bulk of his consciousness is occupied with the more important aspects of design and aesthetic considerations. In this respect, there is an analogy to be drawn to the concert pianist, who, though never consciously aware of each and every one of his fingers, has total control of the final result.

What follows is the information and data that must be understood and mastered by the beginning photographer so that he can make the many technical decisions he is bound to be faced with, with ease. Once this is accomplished, the photographer can bring his natural talents into play and use the camera as a natural extension of his vision.

17

Chapter One

THE CAMERA

Every month or so a friend or a friend of a friend will phone seeking advice as to what kind of camera to buy. Inevitably, their interest lies in 35mm and just as inevitably, the caller will sooner or later get around to asking, "What is the *best* camera?"

The question is impossible to answer. There is no *best*. This, of course, flies in the face of one of the cardinal tenets of consumerism. Nevertheless, a Ferrari is not going to make a LeMans winner out of the guy who uses his car to commute daily between Scarsdale and Manhattan. Neither, of course, will a Leica make a Cartier-Bresson out of a beginning photographer. *Best*, at least as far as photographic equipment is concerned, is what suits your needs and your pocketbook.

Most of the name-brand 35mm cameras today are well engineered, durable instruments. Competition has, over the past few decades, created a situation where camera manufacturers have kept each other busy almost annually with new and exciting breakthroughs, improvements in the basic product, design upgrading.

There are of course distinct differences in concept and design between different brands of 35mm cameras, but if you asked a dozen photographers which one they thought was best, you might receive a half-dozen or more different answers, and in each case the individual photographer would probably respond with the name of a camera he currently owned.

For example, the Canon Reflex will stand a tremendous amount of abuse. The Contax is a miracle of electronics. The Leica will outlast its owner and, like the Rolls-Royce, will gain in resale value as the years go by. The Pentax is simple and straight-forward. The rugged Nikon, when worn with a Forscher strap, sans leather case and appropriately battered, is a glamorous piece of jewelry thought to be irresistible to the opposite sex. The Olympus is a marvel of miniaturization. The Minolta is a wondrous and viable compromise of much of the above. You pays your money and takes your choice.

The present cost for a 35mm single-lens reflex camera of reasonable quality ranges from about $200 to roughly $1500. The $200 will buy you a bottom-of-the-line, single-lens reflex with lens interchangeability and no frills—on sale or with a liberal discount. Most of the major camera manufacturers offer these more or less stripped-down cameras at hundreds of dollars less than the glamorous tools at the top of their lines, good, solid, quality cameras carrying valid guarantees. The manufacturer stakes his reputation no less on these cheaper models than he does on their more affluent cousins. The name brand is the same.

Currently, $1500, more or less, will buy you a brand-new, shiny Leica.

Nevertheless, neither the economy model Minolta nor the super precise Leica M5 will ensure creative, exciting pictures. Only the skill and talent of the photographer can do that. The camera is simply a tool.

The function of a camera is to *make photographs*. It is a tool in the hands of a photographer whose function it is to *create pictures*.

All serious cameras (and by that I mean cameras that are not merely automated toys used primarily to make photographs of the family dog or the new baby) have in common, despite their size or format, five very specific functional controls.

1. A means of focusing the lens on the subject.
2. A shutter mechanism with which to expose the film for

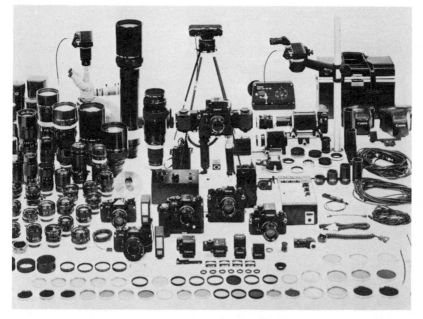

The Canon F-1 *system.* Other cameras with similar systems are: Nikon, Pentax, Leicaflex, Minolta, Contax, Olympus, Alpa, Topcon, and Konica. (For suggested *personal* systems see Appendix One.) *Canon Camera Company*

brief periods of time to the image-bearing light projected through the lens.

2. A diaphragm to control the *amount* of light passing through the lens.

4. A viewfinder or some other device with which to aim the camera and frame the picture.

5. A convenient means whereby an exposed piece of film can be easily replaced by an unexposed piece of film.

All 35mm camera controls, despite their price or degree of sophistication, are restricted solely to these five functions. In this respect they are like the first successful 35mm camera, the 1924 Leica. They also resemble basically the somewhat larger format Ermanox camera used in 1928 by the legendary Erich Salomon, the man for whom the phrase "candid photography" * was coined.

* Erich Salomon, *Portrait of an Age* (New York: Macmillan, 1967).

During the past few decades, refinements have been added to the five basics of the 35mm camera: added conveniences such as rangefinders and reflex pentaprisms take the guesswork out of focusing; built-in electronic exposure meters aid in exposure determination; self-timers enable you to take photographs of yourself; flash synchronization provides the possibility of adequate light where before there was none; electric-motor drives wind the film and cock and release the shutter with extreme rapidity; shutters are electronically timed; LED readouts flash the latest news in the viewfinder. (Some cameras have almost as much electronic gear as your color TV.)

However, none of these improvements adds anything to the camera's primary function. Great photographs were created long before camera manufacturers designed these improvements into the basic structure of the miniature camera.

The five basic controls of the 35mm camera function as follows:

The Focusing Mechanism

Camera lenses, like the human eye, are only capable of *focusing* on one plane. Therefore, like the human eye, the focusing mechanisms of lenses must be adjustable. Accurate focusing is most critical at near distances and less critical as the distance from camera to subject increases.

Lenses for 35mm cameras focus either by increasing or decreasing the distance between the lens and the film or by adjusting the internal optical elements of the lens itself. The changes are usually accomplished by rotating a focusing ring on the lens barrel. The very early 35mm cameras (and a few specialized cameras today) were focused by aligning an index mark on the lens casing with a footage scale on the rotating ring. This was difficult, as it required the photographer to estimate, as accurately as possible, the distance to his subject. In some situations this method required the estimate to be accurate to within a few

inches! A wrong guess could result in a photograph ruined because of unsharp focus. In 1932, Carl Zeiss of Germany began marketing a camera (the Contax) with a built-in rangefinder. This was a device based on the artillery rangefinder and then coupled with the focusing mechanism of the camera. All the photographer had to do was to peer through the special viewfinder and rotate the focusing ring until the two images of the subject coincided. At that point the camera was focused.

The rangefinder made the 35mm camera into a practical precision instrument. For three decades, the rangefinder camera ruled the 35mm roost. The German Contax and Leica were the most sought after before World War II, and after the war the Japanese produced and exported the Nikon and Canon. The Nikon was a copy of the Contax. The Canon was a replica of the Leica. Soon, however, the Japanese began to innovate, and by the middle fifties their products were widely accepted by American professionals. At this writing, there is only one serious 35mm rangefinder camera being manufactured: the Leica M5. The rangefinder camera was replaced in popularity in the sixties by the *single-lens reflex* (SLR). A few manufacturers, however, had been making SLRs for decades. Notable among these cameras was the Exacta, an East German import. However, general acceptance of the SLR did not come about until the Japanese Pentax hit the American marketplace in the late 1950s. The Pentax was simple and uncluttered and became popular immediately.

The single-lens reflex is today the standard 35mm camera. With it, the photographer actually sees through the camera's lens up to the actual instant of exposure. This is accomplished through the use of a hinged mirror that directs the image-bearing light through a prism into the viewfinder.

The object of all this is accurate focusing. *The eye of the photographer sees what the film "sees."* Since the image is projected onto a ground glass, the photographer can focus on any portion of the scene simply by rotating the lens focusing ring until the subject appears to be sharply focused. A split instant

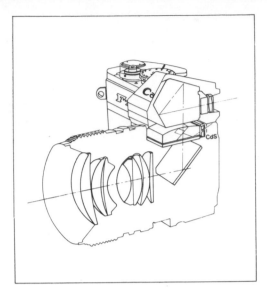

Single lens reflex system.
Minolta Camera Company

after he presses the shutter-release button, the mirror swings up out of the way, the shutter opens and closes, and the mirror flops down, once more projecting the image onto the magnified ground glass.

There are advantages and disadvantages to both the range-finder and SLR systems. The rangefinder camera, in practiced hands, can be focused rapidly and with great accuracy. There is no subjective decision as to whether or not the subject *seems* to be in focus. Either the two images coincide or they don't. The rangefinder is easier to use in dim light, and because it does not require a movable mirror, it is much quieter. Its disadvantages lie in the fact that the viewfinder projects only an approximation of what finally reaches the film. This is not to say that it *sees* a greater or smaller area than the film does, but that the image, as seen by the eye, is always uniform as to planes of focus (see *Glossary*). In addition, the choice of lenses for the rangefinder camera is somewhat restricted.

The advantages of the SLR are two-fold. Since the eye of the photographer sees what is actually being projected onto the film, the planes of focus can be seen and adjusted. (The photographer can actually *see* what portions of the picture will be in or out of focus.) Secondly, since there are no coupling devices to the non-existent rangefinder, and no limit to the accuracy of the ground

glass, the SLR is capable of accepting an astonishing array of lenses and sophisticated optical equipment (from extreme tele-photo and wide-angle lenses, to closeup macrolenses). Of course, there are disadvantages to the SLR. The greatest of these is the vibration caused by the flipping mirror. Manufacturers have dealt with this problem and have succeeded quite well in muffling it to the point where, under normal picture-taking conditions, the effect is almost nil. However, when using slow shutter speeds care must be taken to offset the residual mirror vibration. Another disadvantage is the momentary viewfinder blackout that occurs during the brief instant when the mirror is in the *up* position. This may strike the reader as being minimal; however, in some circumstances, long exposures (over 1/15 sec.) can create a problem.

The Iris Diaphragm

The diaphragm is an integral part of the lens and is controlled by turning a ring on the lens barrel. The diaphragm consists of rotating metal wedges which dilate or contract a pupil-like open-ing and thus control the amount of light that will pass through the lens and onto the film. The size of the opening is expressed in f/stops,* thus:

f/1.4, f/2, f/2.8, f/4, f/5.6, f/8, f/11, f/16, f/22

(These numbers are engraved on the lens barrel and aligned by the photographer with an index mark.) *Each f/stop transmits twice the light of the one following it.* Therefore, f/2 will pass twice the light through the lens and onto the film as will f/2.8, and four times more light than f/4.

The smaller the number, the larger the opening or aperture in the diaphragm. The larger the aperture, the greater the *ex-posure.* A specific aperture or exposure is usually referred to as a

* The f/stop is computed by dividing the diameter of the diaphragm opening into the focal length of the lens.

stop. If you were, for example, to increase your exposure (use a larger aperture) from *f*/8 to *f*/2.8, you would be *opening up* three stops. If, on the other hand, you were to decrease your exposure (use a smaller aperture) from *f*/11 to *f*/16, you would be *stopping down one stop.*

Smaller f/stop Larger f/stop

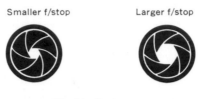

The iris diaphragm.

There are situations where, for example, a filter might call for an *exposure increase* of 8X. This means that if you were using an aperture of *f*/11, you would open up three stops to *f*/4. (One stop = 2X, two stops = 4X, three stops = 8X.)

In addition to the full *f*/stop series displayed above, there is an additional series of *f*/stops referred to as *half stops.* Half stops designate aperture openings that fall in between the full stops.

The diaphragm control rings on most lenses today have extra click stops between the engraved full *f*/stop values, so that even though the half stops are not designated on the lens barrel, they can be utilized simply by placing the diaphragm index mark between two full *f*/stops. This presents the photographer with a little more control over his exposure, enabling him to increase or decrease the aperture by as little as 50% rather than restricting him to gross changes of 100% as represented by full stops. In other words, stopping down from *f*/4 to *f*/6.8 would indicate an exposure decrease of one and a half stops—*f*/4 − *f*/5.6 = 1 stop; *f*/5.6 − *f*/6.8 = ½ stop. Total = 1½ stops.

In photographic parlance, the widest aperture of a given lens designates its *speed.* Simply put, the lens whose widest aperture is *f*/2.8 has a "speed" of *f*/2.8, or even more simply, *it is an f/2.8 lens.* (The term "speed" when used in this sense should not be confused with shutter speed.)

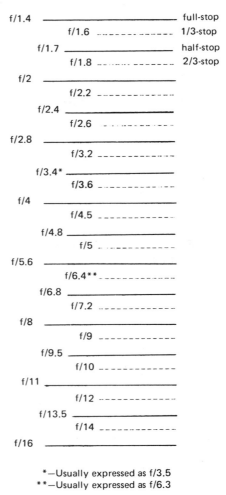

f/1.4 —————————	full-stop
f/1.6	1/3-stop
f/1.7 —————————	half-stop
f/1.8	2/3-stop
f/2 —————————	
f/2.2	
f/2.4 —————————	
f/2.6	
f/2.8 —————————	
f/3.2	
f/3.4* —————————	
f/3.6	
f/4 —————————	
f/4.5	
f/4.8 —————————	
f/5	
f/5.6 —————————	
f/6.4**	
f/6.8 —————————	
f/7.2	
f/8 —————————	
f/9	
f/9.5 —————————	
f/10	
f/11 —————————	
f/12	
f/13.5 —————————	
f/14	
f/16 —————————	

Half-stops are usually indicated on many lens diaphragm controls through the use of a click stop or detent. Meters, including camera meters, are calibrated in third stops. It follows then, that lens makers and meter manufacturers are somewhat out of sync with each other. We can only hope that perhaps some day . . .

*—Usually expressed as f/3.5
**—Usually expressed as f/6.3

Photographers speak of lenses as being *"fast"* or *"slow."* A fast lens has a wider maximum aperture than does a slow lens. Generally, in 35mm photography, an $f/2$ lens is considered fast and anything smaller than an $f/3.5$ lens is considered slow. In very loose terms, the speed of a lens is related to its selling price. Fast lenses are usually more expensive (in any given focal length) than slow lenses. For examples, a 200mm, $f/3.5$ telephoto lens

will probably cost more than a 200mm, *f*/4 telephoto lens of equal quality.

To sum up, the function of the diaphragm is to give the photographer control over the *amount* of light that reaches the film. This function, as will be explained, is shared in a somewhat different manner by the shutter.

The Shutter

The opening and closing of the shutter exposes the film to image-bearing light. The length of time that the shutter remains open, relative to the *f*/stop, determines the *exposure*. To reiterate, the *f*/stop, or lens opening, controls the *amount* of light that passes through the lens while the shutter speed determines the *duration* of the exposure.

Shutter speeds are controlled, on most 35mm cameras, through the use of an indexed dial situated on the top plate. Practically all 35mm cameras today have focal-plane shutters. A focal-plane shutter consists of a slitted curtain or similar device that travels horizontally just in front of the film.* The slit or opening, as it moves from one side to the other, exposes the film to the image being projected through the lens. The width of the slit relative to its speed of travel determines the *shutter speed*. Shutter speeds are designated in fractions of a second. Thus, a speed of ¼ sec. indicates that the film will be exposed to the image-bearing light during that slice of time. The range of shutter speeds usually starts with a full second and continues through to a thousandth of a second in the following increments:

1, ½, ¼, 1/8, 1/15, 1/30, 1/60, 1/125, 1/250, 1/500, 1/1000

A few inexpensive cameras range from ½ sec. to 1/500, and a few more expensive models range from as long as 20 or more seconds to 1/200. You will note that *each shutter speed is*

* Other types of focal-plane shutters, such as the metal Copal shutter, operate somewhat differently, but the principle is the same.

roughly twice as long as the one following it. For example, a shutter speed of 1/15 sec. is four times slower than a shutter speed of 1/60 sec., and therefore will expose the film to four times the amount of light.

Most shutter mechanisms are mechanically timed, though there are a few cameras that possess electronically timed shutters. Both have their advantages and disadvantages. Electronically timed shutters are generally more accurate than all but the most expensive mechanical shutters. Their main disadvantage is that because they require electric current, they are subject to failure when batteries go dead.

The Viewfinder

The viewfinder on an SLR camera, as explained earlier, permits the photographer to view, through a built-in magnifying lens, an image of the subject projected onto a ground-glass viewing screen. The image-bearing light passes through the camera lens, is diverted upward at a 90° angle by a mirror into a prism, which erects the image and corrects it right and left while diverting it a full 90° once again so that it ends up parallel to the lens plane.

Camera manufacturers supply diopter correction lenses that attach to the viewfinder lens, enabling photographers with eye disabilities (nearsightedness, farsightedness) to use the camera without having to wear eyeglasses.

The viewing screen in a 35mm SLR "sees" almost exactly the same area that the film sees (regardless of the lens being used). The term "almost" in this context is important, as on some cameras there is a miniscule difference, whereby the developed film will show a slightly greater area than that which had been framed by the viewfinder. The reason for this tiny discrepancy in framing is to compensate for the cardboard masks in which color transparencies are mounted. The slide masks are usually slightly smaller than the full 35mm frame size.

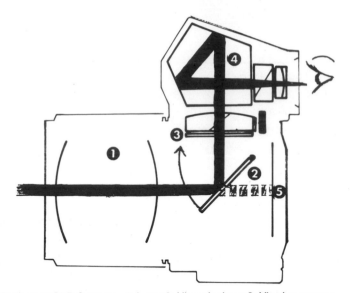

Viewing System of SLR Camera—1: Lens; 2: Hinged mirror; 3: Viewing screen; 4: Pentaprism; 5: Film plane. Heavy line denotes light path through viewing system. Broken line leading to the film plane indicates the light path when the mirror is in the *up* position.

Non-SLR cameras, or more specifically, the few 35mm cameras that depend on a rangefinder for focusing, have separate viewfinders. The viewfinder, of which the rangefinder is an integral part, possesses its own optics and therefore does not depend on the camera lens to supply the image. Because of the nature of a viewfinder system, rangefinder-type cameras do not project the finder image onto a ground-glass viewing screen but rather, like a telescope or similar optical instrument, project the image directly into the eye of the viewer.

Since the viewfinder is a separate and self-contained system, some means must exist to supply framing to suit a large number of different lenses. The Leica M5 solves this problem by providing masks which outline, in the finder, the appropriate field for lenses from 35mm wide-angle to 135mm telephoto.

Viewfinders on rangefinder cameras, because they are above and sometimes to the side of the camera lens, view the subject from a slightly different angle from the camera lens itself. The result can be incorrect framing, with the camera framing the

picture somewhat below the one seen in the finder. This difference is especially critical when shooting close-ups, and, if not taken into account, can cause decapitations. The phenomenon is called "parallax." Parallax is defeated in well-engineered rangefinder-type cameras by a device that tilts and shifts the finder optics downward and sideways in direct proportion to the subject distance.

Film Transport

All modern 35mm cameras are wound and cocked through the use of a lever on the right side of the camera. The lever winds the film to the next frame and "cocks" the shutter, readying it for the next exposure. A further function of the cocking or winding lever is to advance the film counter, so that the photographer may know how many frames he has left on the roll. When the counter reaches 20 or 36 frames (depending on the length of the film roll) or when the cocking lever jams and will wind no more, it is time to rewind the film. This is accomplished by pressing or turning the rewind button and cranking the film back into the cassette, using the rewind crank usually found on the left side of the camera body. A note of caution: when winding film, do not attempt to force the lever beyond the point where it jams at the end of a roll, or you may rip the film out of the cassette.

Some cameras have a ratcheted cocking lever that enables the photographer to advance the film and cock the shutter in a series of small arcs if he chooses. This is a decided convenience over the nonratcheted cocking lever in that it does not have the tendency to displace the shutter finger.

A few cameras provide accessory, electric motor drives. These devices attach to the camera body and actually wind the film and cock and release the shutter. Some of them are capable of machine gun–like speed of over six shots a second. A few cameras, such as the Minolta XM-Mot, have motor drives actually built in, rather than as attached accessories. (Engineering-wise, this is by far the better configuration.)

Chapter Two

CAMERA FEATURES

Lens Interchangeability

It can be said that, except for special circumstances, any 35mm camera that does not have lens interchangeability is half blind. Fortunately, almost all 35mm reflex cameras have this facility, but of the many rangefinder cameras currently on the market, only two are so equipped.

A vast array of lenses are adaptable to the 35mm reflex camera—for some of the more popular cameras, there are as many as one hundred or more. However, with but a few exceptions, lenses are not interchangeable between the different brands of camera. Each manufacturer has designed his own exclusive mount to accept only those lenses made specifically for it. In addition to the lenses manufactured by the individual camera makers for their own products, there are also independent lens makers who design and merchandize complete lines of lenses adapted to many different cameras. Such lenses are usually less expensive than those made by the camera people themselves.

The reflex camera will accept an almost infinite variety of lenses, since no mechanical linkage or secondary optical systems separate the photographer from his subject, as they do with rangefinder cameras. Wide-angle lenses, capable of encompassing fields of view as wide as 220°, telephoto lenses able to record the grimace of a tackled quarterback from a hundred

yards away, macrolenses which can fill the frame with the gossamer structure of a butterfly's wing, zoom lenses, focal-shift lenses, soft-portrait lenses, fish eye lenses, perspective correction lenses, catadioptric lenses, short-mount lenses, closeup lenses, bellows attachments, slide copiers, microscope adapters, telescope adapters—lens interchangeability makes the 35mm reflex camera the most versatile photographic instrument that ever existed!

As mentioned before, only two of the rangefinder cameras can accept interchangeable lenses. Of the two, the Leica M5 is the more professional instrument. Though a superb camera (as were all its predecessors), the M5 is restricted for all practical purposes to a much narrower variety of lenses. Because of the inherent limits of its rangefinder mechanism and the independent viewfinder, the M5 (and any other rangefinder cameras of the past or future) is restricted to lenses with focal lengths ranging from 35 mm to 135mm—moderate wide-angle to moderate telephoto.* This limitation is not necessarily a drawback. The ease of handling and the quiet assurance of any Leica rangefinder camera, past or current, are a joy. The camera comes readily to hand and operates in dim light situations as no other camera can. It has long been a favorite of photojournalists.

The Automatic Diaphragm

The autodiaphragm function is found on most 35mm reflex cameras and lenses. Its purpose is to hold the lens diaphragm at its widest aperture until the shutter is released. The viewfinder thus remains at maximum brightness for ease of viewing and focusing, with the autodiaphragm closing down only at the instant of exposure to the f/stop preset on the aperture ring. When the exposure is complete, the diaphragm reopens once more to its maximum aperture.

* Wide-angle lenses of focal lengths shorter than 35mm may be used along with separate (shoe-mounted) viewfinders.

Assuming an $f/2$ lens (maximum aperture) set for an exposure of $f/16$, the viewfinder image will be 32X brighter with an autodiaphragm than without one.

There are lenses that lack autodiaphragm mechanisms. Some of these have a manual feature, whereby the f/stop is preset, then focusing is accomplished (wide open), followed by a manual twist of the preset ring which stops the lens down to its predetermined aperture just before the shutter is released. Some extremely long telephoto (and long focal-length) lenses fall into this category. There are a number of inexpensive lenses, manufactured by independent lens producers, that also lack the autodiaphragm.

For reasons that will be discussed in later chapters, there are times when it is advantageous to bypass the autodiaphragm and view the image with the lens in its stopped-down mode. This is accomplished through the use of an autodiaphragm defeat button, usually known as a *preview button*. The preview button is located on the camera body or in a few instances on the lens itself. It is an important feature. Rangefinder cameras do not require autodiaphragms.

The Built-In Exposure Meter

An exposure meter is a device that, through the use of a photoelectric cell, measures the amount of light.

Initially, exposure meters were small, pocketable units, which today are referred to as *handheld meters*. They are still manufactured and are considered indispensable as photographic tools, despite the fact that most 35mm cameras today have built-in meters. As is explained in greater detail in a later chapter, the function of an exposure meter is to *read* the amount of light falling on it and transfer that information to a readout which will enable the photographer to determine the proper f/stop and shutter speed combination. In the 35mm camera, this readout or

indicator is usually displayed in the viewfinder in the form of a moving needle. To arrive at the proper exposure, the needle (displaced by the amount of light striking the meter cell) is aligned with an index mark that responds to *f*/stop and shutter speed adjustments made by the photographer. Thus, when a correct shutter speed and *f*/stop combination is set, the needle will be aligned with the index mark. Some cameras use light-emitting diodes in the viewfinder instead of a moving needle, but the basic principle is the same.

Built-in exposure meters are nothing new in 35mm photography. They existed for many years in the form of *external* photoelectric cells, which *read* the same general area regardless of what lens was on the camera. They were essentially *separate* exposure meters attached to, rather than part of, the camera.

In the late fifties, a Topcon 35mm reflex camera went into production which placed the meter behind the lens, *inside* the camera body itself. This was the first behind the lens (*BTL*) meter. Its greatest advantage lay in the fact that the photographer could adjust his exposure without moving the camera from his eye.

The BTL meter registers only that part of the light that enters the camera through the taking lens, regardless of the lens being used. It thus ensures that no extraneous area will be read, which often happens when external meters are employed. Today, practically all 35mm reflexes make use of BTL meters.

Currently, as previously noted, with but two exceptions, rangefinder cameras do not possess interchangeable lenses, and therefore make do quite well with meters that locate their light-sensitive cells externally. Only the rangefinders Leica CL and Leica M5 possess BTL meters.

Flash Synchronization

All 35mm cameras, of whatever persuasion, possess the ability

to synchronize their shutters with the discharge of a flashbulb, or electronic flash unit.*

The flash unit is plugged into a receptacle on the camera, through the use of a wire lead. The wire is termed a *PC cord,* the receptacle, a *PC outlet.* A shoe mount atop the camera is usually provided into which the flash*gun* (bulbs) or flash unit (electronic flash) can be mounted. Some cameras provide an electrical contact in the shoe itself, for use with flash units similarly equipped, thus doing away with the necessity for PC cords. This device is called a *hot shoe.*

Flashbulbs come in a few varieties, requiring varying electrical "delays." Such bulbs are designated "X," "M," or "FP." Generally, 35mm cameras are equipped to handle most types, either through the use of a switch or through the use of two separate PC outlets.

The "X" sync, so designated on the camera, is primarily used for electronic flash, and indicates a *zero delay.* The electronic flash is fired automatically at the instant the focal-plane shutter is wide open. Since such flash duration is very short (1/400 sec. to 1/20,000 sec.), the shuttter curtain *must* be wide open and at an absolute standstill when the electronic flash is fired. Anything less will cause a cut-off, leaving a portion of the frame unexposed. The maximum shutter speed at which the shutter opens completely is usually designated as the camera's *sync speed.* At higher than sync speed, the shutter curtain is never completely open, but operates as a kind of traveling slit. And so, some flashbulbs, particularly those designated FP (focal plane) have long peaks of 1/25 sec. or longer, and literally paint the film with light as the shutter slit travels across the film plane. Therefore, electronic flash is restricted to focal-plane shutter speeds (syncspeeds) of no higher than 1/125 sec. (1/60 on many cameras), while the FP flashbulb will synchronize at any speed.

* Sometimes incorrectly called "strobe." (Strobe refers actually to a *rapidly repeating* electronic flash.)

The Removable Pentaprism

There are a number of 35mm reflex cameras sporting this feature. It enables the photographer to remove the prism housing from atop the camera and replace it with other viewing devices. Focusing screens, of varying types, can also be replaced.*

In addition to interchangeable viewing screens, the removable-prism camera offers the advantage of using various other devices such as waist-level finders, high magnification finders, super-sensitive meter booster finders, action (or speed) finders, and even pentaprism servofinders, which set the proper f/stop automatically.

With just a few exceptions, reflex cameras with interchangeable finders house their BTL meter cells within the prism housing. Therefore, in such cases, when the pentaprism is removed, the meter is removed along with it. This presents a problem, in that accessory viewing devices must have their own metering systems, or, as is quite often the case, do without. There are, however, just a few removable-prism cameras (such as the Canon F-1) that plead innocent to this charge and have placed their meters within the camera body itself, thus retaining their metering facilities, no matter what type of viewing device is used.

The Viewfinder Readout

A great luxury, available on many cameras, the viewfinder readout enables one to monitor some or even all of the camera's functional controls, without the necessity of removing one's eye from the finder. Marvelous idea!

Being able to see the indicated shutter speed, and/or f/stop in the viewfinder is somewhat analogous to a pilot of a 707 being able to read the instruments clustered around his windshield. Lowering the camera from your eye in order to check its settings

* In a few reflex cameras, such as the Olympus, the viewing screen can be changed, despite the fact that the prism housing is not removable.

12 Basic Focusing Screens

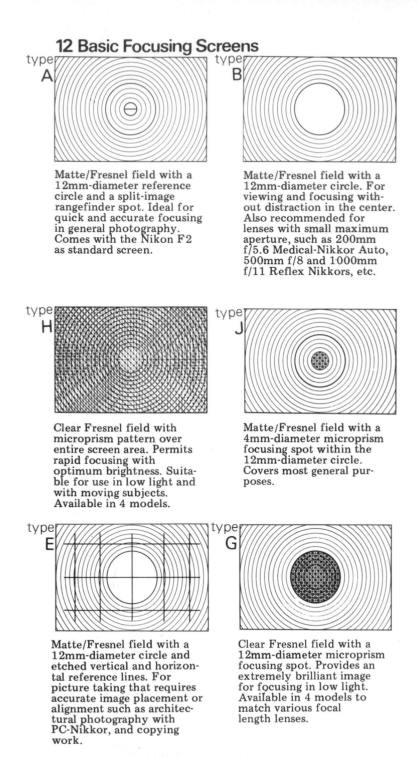

type A

Matte/Fresnel field with a 12mm-diameter reference circle and a split-image rangefinder spot. Ideal for quick and accurate focusing in general photography. Comes with the Nikon F2 as standard screen.

type B

Matte/Fresnel field with a 12mm-diameter circle. For viewing and focusing without distraction in the center. Also recommended for lenses with small maximum aperture, such as 200mm f/5.6 Medical-Nikkor Auto, 500mm f/8 and 1000mm f/11 Reflex Nikkors, etc.

type H

Clear Fresnel field with microprism pattern over entire screen area. Permits rapid focusing with optimum brightness. Suitable for use in low light and with moving subjects. Available in 4 models.

type J

Matte/Fresnel field with a 4mm-diameter microprism focusing spot within the 12mm-diameter circle. Covers most general purposes.

type E

Matte/Fresnel field with a 12mm-diameter circle and etched vertical and horizontal reference lines. For picture taking that requires accurate image placement or alignment such as architectural photography with PC-Nikkor, and copying work.

type G

Clear Fresnel field with a 12mm-diameter microprism focusing spot. Provides an extremely brilliant image for focusing in low light. Available in 4 models to match various focal length lenses.

Assortment of various focusing screens available for the NIKON-F and F-2.

type
C

Fine matte field with a cross-hair reticle in a clear 4mm-diameter center spot. For photomicrography and astrophotography, and other applications involving high magnifications, for parallax or aerial-image focusing. Requires viewfinder with focusing control. (6X finder or 2X magnifier, both with variable diopter eyepiece.)

type
D

Overall, fine matte field ensures unobstructed viewing. Used especially with long telephoto lenses or for close-up work.

type
K

A combination of Types A (split-image) and J (microprism) screens. Rapid and accurate focusing. Suitable for general photography.

type
L

Similar to Type A screen, but with the split-image rangefinder line at a 45° angle. Especially effective when focusing on an object with horizontal lines.

type
M

With a double cross-hair reticle and scales on a clear surface. Recommended for photomicrography, close-ups and other work involving high magnification. Requires viewfinder with focusing control. (6X finder or 2X magnifier with variable diopter eyepiece.)

type
P

Matte/Fresnel field with a central 3mm-diameter split-image rangefinder divided at a 45° angle. A 1mm-wide microprism band and a 12mm-diameter reference circle surround the rangefinder. Has etched horizontal and vertical lines to facilitate composition. Suitable for general photography

Nippon-Kogaku

now seems as primitive as the pilot climbing out on the wing to check his air-speed indicator.

Viewfinder readouts on various cameras supply the following information:

Chosen shutter speed
Chosen *f*/stop
Meter indication (matched needle)
Meter indication (light-emitting diodes)
Meter limitation warning indicator

Viewfinders readouts on autocameras go even further:

Camera chosen shutter speeds
Camera chosen *f*/stop
Manually set *f*/stop
Manually set shutter speed
Automanual mode indicator
Meter limitation warning indicator

Viewfinder readouts are engineered differently on different cameras. Some are operated through mechanical linkage, some through electronic means. At least one camera provides light-emitting diodes that light up much the same way as does the time on a digital watch. I personally find this quite distracting, and because this gimmick readout is, at best, an approximation, it is somewhat inaccurate. The simplest expediency is the system used by Minolta whereby a tiny periscope device actually focuses on the *f*/stops engraved on the lens barrel.

Viewfinder readouts are a boon to the near-sighted. For those of us who prefer diopter correction lenses (attached to the viewfinder) to the wearing of glasses, it is no longer necessary to fuss with specs every time we remove our eye from the finder in order to change *f*/stops or shutter speeds.

The Self-Timer

This is a spring-loaded or electrically operated device which delays the action of the shutter release for up to about 15 sec. It is usually cocked through the use of a lever mounted on the front of the camera body, and activated by a small release button. It has a few uses, the most popular being the making of self-portraits. Some self-timers offer a variable delay, controlled by setting the cocking lever only partway into the fully cocked position.

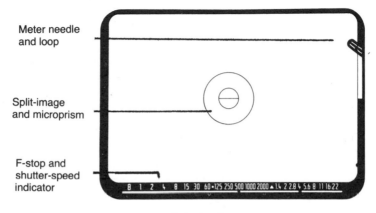

Leicaflex SL-2 Viewfinder.
E. Leitz Inc.

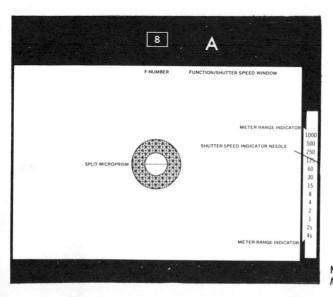

Minolta-XE7 Viewfinder.
Minolta Camera Company

Chapter Three

THE AUTOMATIC CAMERA

Automatic cameras do not take pictures *automatically*—photographers are still required for that function (for which we give thanks). Automatic cameras merely use (or amplify) the signal from a photoelectric cell to set either the shutter speed or the f/stop (or both) relative to the amount of light being reflected from the subject. Through the means of a complex electronic or mechanical system, they relieve the photographer of the necessity of matching needles or diodes in the finder.

All is not magic, though. The light metering function of auto-cameras is no more or no less accurate than that of non-auto-cameras. The same principle applies—that of measuring reflected light. Chapter 11 explains in detail its idiosyncrasies. Suffice it to say at this point that a degree of photographic wisdom is required to interpret the readouts of any reflected-light meter in, on, or removed from the camera—more on this shortly.

The first totally automatic camera was marketed by Eastman Kodak in the late 1930s. It was called the Super-620, a folding rangefinder type. It disappeared shortly before World War II, and not much was heard from autocameras for about a decade. The problem was the relative insensitivity of the selenium photocell which was the standard at the time. It was the appearance of the more sensitive cadmium sulfide cell (CDS) that made autocameras a practical idea.

42

Instead of generating a minute electrical current when struck by light, as the selenium cell did, the CDS cell modulates an externally produced current relative to the amount of light striking it, and therefore has a far greater sensitivity potential. Just the thing for autocameras.

The first postwar autocameras were inexpensive snapshooters, Polaroid cameras, and 8mm movie cameras. Philosophically, the professional and the advanced amateur were totally opposed. In fact, there was actually no contest, as the professional, until well into the sixties, hadn't even gotten around to accepting the *non-auto,* built-in meter (BTL). The serious amateur wasn't very far ahead of him in this respect. (Never is.) There was something impure, something patronizing, about a camera that told you how to set it. And of course a camera that actually set itself was (and still is in some quarters) a TOTAL insult.

Nevertheless, in recent years a few serious autocameras have appeared on the market, and more than a few serious photographers have begun to agree, albeit ruefully, that perhaps there is something here that bears looking into.

The breakthrough was due to the fact that manufacturers began building options into their bright, new, *not-so-shiny* automated reflexes. (Bright chrome is rapidly being replaced by a non-scratch-resistant "professional" cosmetic black.) The photographer now has the ability to modify the camera's "decision" as to what is the proper exposure in any given situation through the use of a simple control which can add to or subtract as much as two stops from the automated exposure. Since everything is monitored in the viewfinder (see illustrations above), the photographer remains in control at all times. If he desires, he can even declare the automatic function of his camera null and void— bypassing it completely.

The autocamera concept was applied initially on cameras that did not provide lens interchangeability. The basic problem in designing an automatic, interchangeable lens, camera was related to the coupling that would be required between the lens and the

camera. This was solved initially by the Konica Auto Reflex through the use of a mechanical system of linkages based on the concept of a caged needle. The photographer set the shutter speed and the camera set the f/stop. Fine. It is a system that works as well as any, except that all the lenses made for earlier Konica cameras were unusable on their new autoreflex. The linkage between camera and body was simply not there, and a new and complete line of autolenses became necessary.

This was too radical a step for other manufacturers to take. Minolta, Nikon, and a few others produce more than cameras, they produce *systems*. A true camera system consists of a large group of cameras, lenses, and accessories, all of which are totally interchangeable.* The photographer who purchases a Nikon, for instance, is guaranteed within reason that his equipment will not become obsolete because of new lenses or accessories or camera bodies that are not compatible with the one he already possesses. For example, it is nice to know that the thousand dollars you spent two years ago for a black-bodied Zubrik K2a and a few lenses remain a valid investment and that when the new Auto-Zubrik EE1 comes on the market, you can restrict your purchase to just a camera body secure in the knowledge that all your previously purchased Zubrik X lenses will fit it and operate in the auto mode with no restrictions or drawbacks.

Therefore, it took a little while longer for the *system* manufacturers to come up with the engineering that would enable them to build totally compatible automatic cameras that would fit snugly into their lines. The answer, of course, was an electronic rather than a mechanical system of linkages.

On this new generation of autocameras, the meter cell controls the shutter speed, rather than the f/stop. Therefore, a separate line of lenses with autolinkage to the camera was not necessary. Shutter speed is arrived at automatically according to the amount

* A few exceptions— Some systems do not have motor drives that are interchangeable on all their models.

of light striking the BTL cell and relative to the *f*/stop preset by the photographer. In the automode, one changes shutter speeds by adjusting the aperture ring on the lens. As the lens is stopped down, the shutter-speed indicator in the finder designates a slower speed. Conversely, as the lens is opened to a wider aperture, the shutter speed increases.

Shutter Preferred and Aperture Preferred Autocameras

So now there are two types of autocameras: *shutter preferred,* wherein the photographer chooses the shutter speed and the camera chooses the *f*/stop, and *aperture preferred,* wherein the photographer chooses the *f*/stop and the camera chooses the shutter speed. Relative, of course, in both cases to the amount of light striking the BTL meter cell.

Shutter Preferred

Advantages: (1) Many photographers prefer setting their own shutter speed, in the belief that it is the more important of the two options. For example, where a high shutter speed is required at an auto race, a 1/1000 sec. speed would remain constant while panning, regardless of shadows or light changes. (2) Lower initial cost.

Disadvantages: (1) Complex mechanical coupling resulting in a higher frequency of repair. (2) An inability to adapt to previous lenses and accessories. (3) An inability to retain autofunction through telescopes, microscopes, and, in most cases, bellows and lens extensions.

Aperture Preferred

Advantages: (1) An almost infinite variety of electronically governed and highly accurate shutter speeds. (The meter is quite capable of setting shutter speeds of 1/328 or 1/94 sec., etc.) (2) Fewer moving parts, thus less maintenance. (3) System com-

patibility. (4) Ability to retain autofunction through almost any type of optical device. (Telescopes, extension tubes, microscopes, bellows, mirror lenses, etc.)

Disadvantages: (1) Higher initial cost. (2) Shutter speed may change because of varying light during situations when high shutter speeds are desirable (and there is no time for monitoring).

There are three very important factors to consider when purchasing an autocamera. First, there should be a means of modifying the meter's decision through the use of an exposure adjustment control. Such control should offer a minimum option of plus or minus two stops either way.* Second, a means by which the automode can be dispensed with during the many situations when it is impractical. (More on this in later chapters.) And third, a complete readout in the finder, showing the f/stop and shutter speed in use and reflecting any change made through the use of the exposure adjustment control.

An autocamera lacking any of these three facilities should be avoided. It will be a camera over which the photographer has little or no control—a camera that will be making the major (exposure) decisions *behind the photographer's back.* And, of course, as this book will constantly stress, it is *you, the photographer,* who must remain in control at all times. Electronic wizardry notwithstanding, a camera, even a sophisticated autoreflex, is still only an inanimate object, while you—all of us—are sentient beings with reasoning power. The camera is a *tool.* Think of it as some sort of magical device and you come up with a situation where the ax is swinging the woodsman.

The best way to deal with the autocamera is to think of it as a conventional camera that has a convenient autofeature, which from time to time can serve a very useful function.

* This function can also be carried out by using a conveniently placed ASA control dial.

Chapter Four

LENSES

All photographic lenses are categorized according to aperture and focal length.

Aperture (F/Stop or "Speed")

By way of review: A lens has an iris or a diaphragm which functions like the pupil of the human eye. The iris dilates or contracts according to the amount of light present: a small opening for brightly lit subjects, a larger opening for dimly lit subjects. The brighter the light, the smaller the lens opening.

As explained in Chapter One, the term "f/stop" relates to a designation common to all modern photographic lenses. As the lens diaphragm is contracted, or "stopped down," the f/stop designation changes. The number grows as the opening decreases.

The f/stop designation when applied to the widest aperture of any given lens determines its maximum "speed" and is used to define the lens. Thus we might have a 90mm f/2.8 or a 400 mm f/6.3 lens.

Focal Length

Focal length is usually expressed metrically. It is measured

17mm (Extreme Wide Angle) 28mm

50mm (Normal) 100mm (Moderate Telephoto)

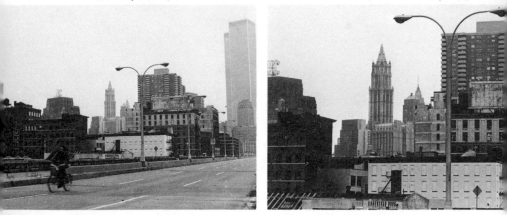

Above and Facing Page: Eight lenses and their relative magnification properties. Note that lenses with focal lengths shorter than 50mm tend to increase the optical distance while lenses longer than 50mm tend to decrease it. Objects in the photographs taken with lenses under 50mm seem further away, while objects in the photographs taken with lenses longer than 50mm seem closer.

from the optical center of the lens to the film plane in the camera. Long lenses are also known as "telephoto" lenses* (incorrectly called "telescopic" lenses) and short lenses are also known as "wide-angle" lenses. Long, or telephoto, lenses tend to flatten perspective, while short or wide-angle, lenses exaggerate perspective (make long noses longer, for example).

* The term "telephoto," within the context of this book, is to be interchangeable with the term "long-focal-length." Despite the fact that the two may differ in terms of optical formula, they function similarly.

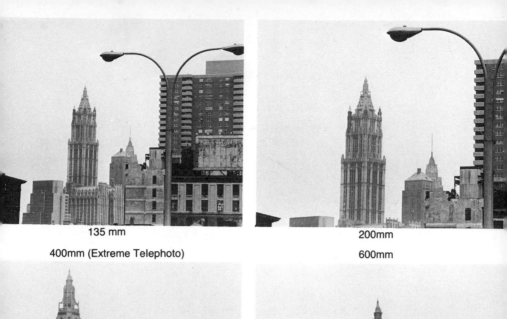

135 mm

200mm

400mm (Extreme Telephoto)

600mm

Between the two extremes lies a focal length that is called "normal." A normal-focal-length lens is one that most closely approximates the perspective perceived by human vision. When used to cover the 35mm format, lenses from 45mm to 60mm are considered "normal." (The 60mm is somewhat more "normal" than the 45mm lens.) Anything shorter than a 45mm lens, when attached to a 35 mm camera, is considered wide-angle. Anything longer than a 60mm lens is considered a telephoto.

Perspective is controlled in photography by relative focal length. By relative, we mean in relation to film size. For exam-

ple, a 50mm lens when mounted on a 2¼ ″ x 2¼ ″ format Hasselblad is considered an extreme wide-angle lens, while a 50mm lens mounted on a 35mm camera is considered a normal lens. In the case of the larger format Hasselblad, the resultant image would have a wide-perspective distortion.

Lenses manufactured for use on 35mm cameras are not adaptable for use on larger formats. A 50mm SMC $f/1.4$ Takumar, made for the 35mm Pentax camera, for instance, if somehow mounted on a 2¼ ″ x 2¼ ″ Rollie SL66, would not "cover" the larger format. Since the lens was designed to fill the 35mm frame size, the diameter of its projected image would simply not be large enough to cover the larger-sized negative. The result would be a circular image filling only a portion of the 2¼ ″ x 2¼ ″ frame.*

On the other hand, lenses manufactured for larger-format cameras *can* be used with the 35mm reflex camera, and often are. For example, an 80mm lens designed for the 2¼ ″ x 2¼ ″ format and considered a normal-focal-length lens in that configuration, when mounted on an extension of some kind and used on a 35mm camera, would act as a moderate telephoto.

Normal lenses usually have the widest maximum apertures. Though they are generally the fastest lenses available, they are, however, sometimes matched in speed by the faster of the moderate telephoto and wide-angle lenses.

The following chart gives you some idea of popular focal lengths and their maximum apertures. It must be reiterated that these are average, based on what is available in the general photographic marketplace at this writing. There are many exceptions, and their number will no doubt increase with time. As a general rule, the price of any given focal-length lens, made by the same manufacturer, is higher for the wider aperture.

* Actually, the example is purely theoretical, as the 50mm Takumar would be impossible to mount on the Rollie. Lenses made for the 35mm cameras have too short a back focus to be mountable on larger-format cameras.

FOCAL LENGTH (in millimeters)	MAXIMUM APERTURE		
	Small	*Average*	*Large*
20–21	—	$f/4$	$f/2.8$
28	$f/3.5$	$f/2.8$	$f/2$
35	$f/2.8$	$f/2$	$f/1.4$
50	$f/2$	$f/1.4$	$f/1.2$
85–90	$f/2.8$	—	$f/1.7$
100–105	$f/3.5$	$f/2.8$	$f/2.5$
135	$f/3.5$	$f/2.8$	$f/2$
200	$f/4$	$f/3.5$	$f/2.8$
300	$f/6.3$	$f/4.5$	$f/4$
400	—	$f/6.3$	$f/5.6$

There are lenses available with larger maximum apertures than those listed here, but at the moment they are the exception rather than the rule. For example, Canon will manufacture, on receipt of a special order, a 300mm $f/2.8$ fluorite-crystal lens for just a few thousand dollars or so (to enable you to photograph a charging rhino at dusk from a distance of 200 feet).

The Telephoto Lens

The telephoto lens, because of its relatively narrow field of view, tends to "bring far objects nearer" much as does a telescope. Many photographers think of the telephoto solely in those terms—a kind of telescope. This is unfortunate, because an equally valuable function of the telephoto lens is its ability to shorten or flatten perspective. A very valuable creative tool—*the flattened perspective of a photograph exposed through a long lens compresses size relationships.*

Skylines appear as unified masses: near objects are foreshortened and far ones magnified. The sun becomes a monstrous red ball with tiny figures silhouetted in front of it. Seascapes are compressed, the breakers more violent, the following waves massively

overstated. Size relationships are minimized, contracted, compressed. Automobile traffic, head on, is squeezed into the density of a massive traffic jam, the cars seemingly sitting on one another. Yet distant objects, though relatively large on the film, retain a remoteness—despite the apparently foreshortened distance, they still seem unapproachable. The ultralong telephoto image seems to isolate the viewer from the subject of the photograph, as if he were outside looking in, *the eye somehow cued to the fact that it is viewing something it is not actually involved in.* The long telephoto can be a creator of powerful objective images.

The shorter telephotos of from 85mm to 135mm are particularly useful for portraits, as they enable the photographer to remain at a comfortable distance from his subject. The moderate perspective compression tends to flatter, by minimizing long noses, etc. When desired, the same effect is valid for nudes and fashion photographs, where the moderate telephoto slims and enhances, creating longer, more gracefully gentle lines.

A telephoto lens will magnify camera movement to the same degree that it magnifies the subject. A long lens is actually an optical lever—a small movement at the base results in a large movement out at the end of the lever. The best way to combat the problem is to use a tripod. The next best way is to prop or even clamp the camera onto a solid object such as a chair or fence post. There are even devices available that enable you to screw the camera into a tree. When all else fails, get your elbows tight in against your body, take a wide-legged stance, jam the camera up against your forehead, and release the shutter . . . squeeze, don't jerk.

Of course with the camera hand held, the higher the shutter speed, the less chance there is of camera shake and a blurred image on the film. General rule: *a shutter speed equal (or close to) the numerical value of the focal length in use is good insurance against camera movement.* In other words, a shutter speed of 1/125 sec. for a 135mm lens, a shutter speed of 1/60 sec. for a

50mm lens, a shutter speed of 1/500 sec. for a 400mm lens, etc. (A 1/3 sec. is considered the minimum for handheld shooting.) These are minimum recommendations. Naturally, there are many situations when high speeds are impossible to use, but it is a good thing to know from what standard one is deviating. With care and practice almost anything is possible. This author, despite his age and degree of decrepitude, is perfectly capable on good days of holding a 200mm lens at 1/60 sec.—no mean trick.

The Wide-Angle Lens

As the telephoto is objective, the wide-angle is subjective. Short-focal-length lenses provide a function opposite to that of telephoto or long-focal-length lenses. Perspective is widened and expanded, sometimes to the point of obvious distortion. Objects close to the camera tend to appear elongated and larger in comparison to objects farther away. A low-angle picture produced via an extreme wide-angle lens is dramatically distorted, and it is relatively simple to create hovering monsters out of perfectly harmless people. The camera, tilted up at a building, produces a photograph in which the structure seems to be reaching for the sky—its lines converging toward the top. The short-focal-length lens expands interiors, increases distance, and distorts foreground objects to the point where they might overwhelm what lies behind them. A child's head can be larger than a five-story building behind it, a close-up of a pencil can loom over a hundred-story skyscraper.

An important function of the short-focal-length lens of course, is its use in tight situations where it is impossible to back up without running into a wall or falling into a lily pond. But its use should certainly not be restricted to such mundane purposes. The wide-angle lens, when used with imagination, can create magic which, incidentally, is a good reason *not to overuse it*. Too much magic is a bore.

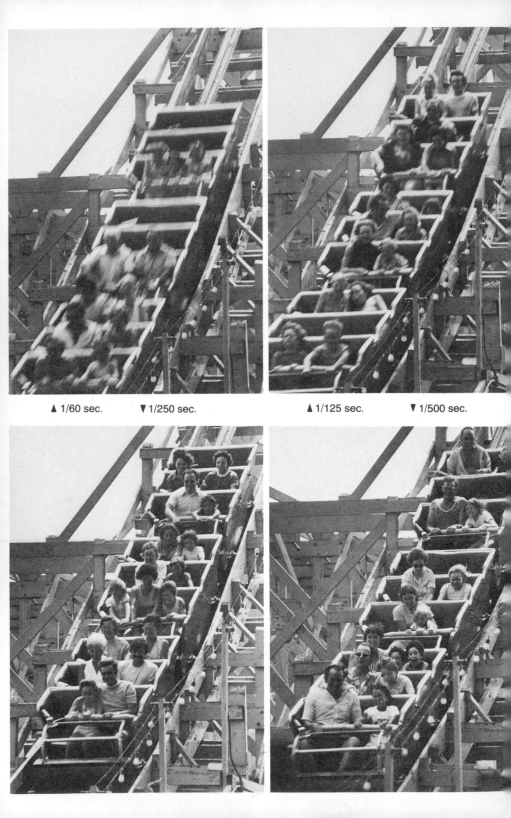

▲ 1/60 sec.　　　▼ 1/250 sec.　　　▲ 1/125 sec.　　　▼ 1/500 sec.

When shooting action, shutter speeds should be related to the speed of the action and its direction of movement relative to the camera. Action at right angles to the camera requires a faster shutter speed than action moving toward or away from the camera. In addition, the larger the image size of the moving object, the faster the shutter speed needed to "freeze" it. These photographs illustrate the action-stopping potential of various shutter speeds relative to an object moving rapidly at 45 degrees off the axis of the camera. A high shutter speed was required because of the large image size.

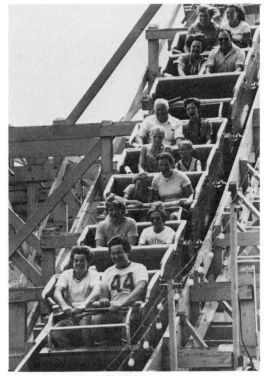

1/1000 sec.

The Zoom Lens

It is called a "zoom lens" because of its original function in motion pictures. Actually, the correct term is *variable-focal-length lens,* which is totally descriptive of its function. However, the misnomer has stuck—it's part of the photographic lexicon and we will live with it in this book.

A zoom ·lens can be set to any focal length within its ratio. A 2 to 1 ratio, for instance, might be a zoom that covers an infinite range between 100mm and 200mm. A popular 3 to 1 zoom lens at this time is the Vivitar Series-One, 70mm to 210mm $f/3.5$ lens. It, like all its cousins and future progeny, can be set at 70mm or 135mm or 180mm or 210mm or any focal length in between. A marvelous tool for the photographer. At best he would need

three separate lenses to equal the zoom function. (We'll discuss the problems and shortcomings presently.)

Zoom lenses come in two types: those with autofocus and those without. Autofocus zooms, when focused at their greatest extension, will retain focus at no matter what focal length they are set subsequently. Nonautofocus zooms require refocusing each time the focal length is changed. The non-autofocusing type has the advantage of greater mechanical simplicity.

Some recent zooms have a semimacro capability that enables them to focus at close ranges of up to one-half life size. None of them do it as well as macrolenses (single focal-length lenses with macrocapability up to life size), but it must be said that one lens that encompasses an infinite number of focal lengths and also operates with fair efficiency and sharpness at extreme close ranges is a handy device to have around when one wishes to travel light.

Zoom lenses have separate controls for zooming and focusing. On some there are two separate rings, on others there is a rotating collar which, when slid back or forth, changes focal lengths. Focusing is accomplished by twisting the same collar right or left. Still other zooms are operated by levers of various kinds, and I'm sure we'll all live to see the day when they are motorized, much as they are on S-8 movie cameras.

Besides the zoom ratio factor, zoom lenses are made in a few different categories: short zooms, such as Leicaflex's 45mm to 90mm Angenieux $f/2.8$; medium zooms, such as the previously mentioned 70mm to 210mm $f/3.5$ Vivitar Series-One; and long zooms such as the 200mm to 600mm $f/9.5$ Nikkor or the 100mm to 500mm $f/8$ Minolta Rokkor X.

All is not milk and honey, though. Zoom lenses have faults, just as you and I. I'll reiterate them:

1. Weight—They are heavy, much heavier and much bulkier than prime lenses of equal maximum focal length. Of course we're speaking of *shooting weight*. It must be admitted that in a gadget bag, compared to the two or three

or more lenses they are meant to replace, it can be an even contest—or better, as far as *shoulder weight* is concerned.

2. They have a smaller maximum aperture than most of the moderately fast lenses within their focal-length range.

3. They are not as sharp as their single cousins. This is due primarily to flare, a phenomenon that will be discussed shortly.

4. Because of the fact that zoom lenses have as many as sixteen lens elements which go to make up their optical formula, *what goes in does not come out.* In other words, there is light loss within the lens itself, due to the natural absorption qualities of even the best optical glass. Each and every glass element of any lens absorbs 4% or more of the light that passes through it. Thus, a fifteen-element zoom lens will transmit to the film only 40% of the light that passes through its front element, as compared to a typical five nonzoom element prime lens, which will transmit 80%. In practical terms, this means that zoom lenses are at least one-half stop slower, at any given f/stop, than prime lenses. Of course when built-in BTL meters are used, this discrepancy is compensated for. However, when judging exposure externally, with a hand meter, for example, the half stop (or more) might be critical. Then, too, the half-stop relative speed loss can, on occasion, create problems in dim-light situations or under circumstances when a faster shutter speed might be called for. Simply put, there are times when you may need every bit of lens "speed" available.

As we pointed out earlier, with but few exceptions, all *serious* 35mm cameras are designed to accept a large variety of interchangeable lenses. Reflex cameras have available to them literally hundreds of lenses, ranging in focal length from the 6mm f/2.8 Fisheye-Nikkor with an angle of view of 220° (a lens which actually includes in its picture coverage an area *behind* the camera), to long-reaching telephotos such as the magnificent

80-200mm Zoom Specifications

Maximum Aperture: f/4.5
Construction: 14 elements in 10 groups
Angles of View: 30° to 12°
Minimum Focus: 6 ft.
Filter Thread Diameter: 55mm
Diaphragm: Fully automatic, f/4.5-f/32
Weight: 24¾ oz.

200mm Specifications

Maximum Aperture: f/3.5
Construction: 6 elements in 4 groups
Angle of View: 12°
Minimum Focus: 8 ft.
Filter Thread Diameter: 62mm
Diaphragm: Fully automatic, f/3.5-f/22
Weight: 27⅜ oz.

Comparison between a zoom lens
and a prime lens, relative to the
number of elements and the
complexity of the lens formula.

Minolta Camera Co.

2800mm f/16 Questar (with a field of view of less than 1°— actually capable of extending to 30,000mm f/170).

The Leica CL and the more sophisticated Leica M5 are, at this writing, the only interchangeable-lens, rangefinder cameras being produced. The exquisitely miniscule CL has an upper limit of 90mm. The M5 will accept lenses up to 135mm. At the wide end of the lens spectrum, 15mm to 35mm lenses are available. However, through the use of the Leitz Visoflex, lenses as long as 560mm may be fitted. (The Visoflex is a reflex housing that converts the rangefinder M5 into a reflex camera.)

Chapter Five

THE EVOLUTION OF PHOTOGRAPHIC FILM

In 1878, Charles Harper Bennett, an Englishman, produced the first gelatine-based photographic plates sensitive enough to expose in a handheld camera (at shutter speeds about 1/25 sec.). Now that the photographer was no longer tied down to the tripod, he could actually, with his new sensitive material, photograph action of the sort never possible before. Gone also was the necessity for processing negatives immediately; now he could hold onto exposed plates for a reasonable time until he had an entire batch to develop at his convenience. For that matter, he could even send them to others for processing.

The photo industry was born.

George Eastman, of Rochester, New York, produced his first camera in 1888. The initial Kodak was a box camera containing a paper roll of a hundred circular negatives. The camera sold for $25, with film. When the hundred pictures had been exposed, the entire camera, film and all, was sent to the plant in Rochester where the film was unloaded, developed, and printed, and returned to the owner, along with his reloaded camera, for $10. *"YOU PRESS THE BUTTON, WE DO THE REST."* We're still pressing and they're still doing . . . probably the world's most successful and happiest symbiotic relationship.

Before the First World War, there had been some activity along the lines of adapting the newly invented, sprocketed 35mm

motion-picture film for use with miniature still cameras, but it wasn't until 1924 that E. Leitz and Co. produced the first commercially successful camera to use this film. It was developed by Oskar Barnack. With great ingenuity, Barnack designed his camera for a larger frame size than the 35mm motion-picture camera. By running the frame lengthwise along the film, instead of across it, he increased the total area of the negative two-fold. Barnack's Leica negative was 24mm x 36mm, standard today for all 35mm cameras.*

Thirty-five millimeter photography was made possible because of the existence of motion-picture, sprocketed film. Without it, the miniature camera might never have proved practical. It was and is a unique instrument, capable of great mobility and versatility, an extension of the eye that, in the practiced hands of talented men and women, has shown us the world and its people as they have never been seen before. Its early practitioners, Cartier-Bresson, Alfred Eisenstaedt, Robert Capa, Bill Brandt, and others invented a new perception that has proved to be not only the most important aesthetic in photography, but also an indispensable tool of history.

Initially, all photographic negative material was blue-sensitive. Black and white film was insensitive to orange, yellow, and red. Blue skies registered a blank white and lips were almost black. A yellow ribbon against a blue background would appear as almost pure, featureless black on white. Later, the orthochromatic ("ortho") plate was invented, which was sensitive to all colors but red. Then, finally, in the 1930s, the first panchromatic roll film was marketed. It was sensitive to all colors.

The search for a means to reproduce color is almost as old as photography itself. Daguerre himself was experimenting with color as far back as the 1820s. Eastman House has in its posses-

* There are a few specialized cameras that use the smaller cine frame. They are called *half-frame* cameras, a misnomer, as the cine frame is officially referred to as *single frame;* the still camera frame, *double frame.*

sion a color daguerrotype made in 1851, by Claude Félix Abel Niépce de Saint-Victor. Unfortunately, he was unable to fix the image, and the few examples still extant must be stored in total darkness.

One of the earliest approaches to color photography was demonstrated by British physicist James Clerk Maxwell when he proved, during an experiment conducted at the Royal Institution of London, in 1861, that all the colors in the spectrum can be created by mixing varied amounts of blue, green, and red light.* Using three lantern slides, each one exposed through an appropriate filter of red, green, or blue (glass cells filled with colored liquid), he projected them in register through three separate projectors, each equipped with its corresponding filter. The result was a photograph in full color projected on the screen. Had photoengraving been what it later became, the three *separations* could have been made into plates and printed in register, much as it is done today.

The first practical *color film* was invented by John Joly, an Irishman, who created a process whereby the three primary filters, instead of being separate, were imposed on a single screen in the form of equally spaced, almost microscopic dots of blue, green, and red. The black and white film, in contact with the screen, was exposed, and after development placed once again in exact register with the filter screen, this time permanently. The result was a single color transparency where the black and white positive image modulated the amount of light passing through the transparency, and the filter grid—each miscroscopic, transparent colored dot—in register with its counterpart on the film, provided the color, which blended into the subtle variations of the original.

Later, in 1907, the brothers Louis and Auguste Lumière put on the market a product called Autochrome, which was a single

* See Chaper Thirteen for explanation of photographic primary colors (blue-red-green) versus pigment primary colors (red-blue-yellow).

film based on the additive process of John Joly. In this case, however, the photographic plate itself was covered with tiny dots of starch, each died red, green, or blue and distributed evenly. The film was constructed in such a way that light passed through the minute filter dots before striking the light-sensitive black and white emulsion. During processing, the negative plate was reversed into a positive, resulting in a color transparency.

Other manufacturers were quick to adapt the Lumière idea. Films and plates appeared bearing such names as: *Dufaycolor, Agfacolor, Alticolor,* and *Filmcolor.* (The last two were manufactured by the Lumières themselves.) Some of these films remained on the market until well into the 1930s.

All of the above were *additive* color processes. The colors, each viewed or projected separately in the form of miniscule red, green, or blue dots, *added* together to form all the colors of the spectrum. The process was satisfactory despite the fact that the resultant product was somewhat *grainy* and relatively unsharp. Later, for reproduction on the printed page (or photographic color prints), color *separations* were necessary. As explained earlier, a color separation is a black and white film record of one of the three primary colors (red, green, or blue). For this purpose, a "one-shot" color camera was developed which exposed three sheets of panchromatic film, simultaneously through beam splitters (two-way mirrors), and then through the three appropriate primary filters. The three separation negatives were then handed to the printer, who used them to make his halftone plates, which, when mounted on a press and inked with complementary colors, produced on the printed page a full-scale color reproduction of the original scene.

Additive color processes depend on the transmission of light from three separate sources (red, green, blue). They require the interpositioning of filters somewhere between the light source and the viewer. As shown above, sometimes these filters are microscopic dots of color, but nevertheless they are an integral part of any additive system. The inner face of a television tube, for ex-

ample, is dotted with miniscule phosphors, each constituted to glow the appropriate color when struck by either red, green, or blue light. Within the tube are three "guns," one which projects the blue separation of the scene with blue light (through a blue filter), one which projects the green separation of the film with green light, and one which projects the red-sensitive separation of the scene with red light. Red-sensitive phosphors glow red when struck with red light, green- and blue-sensitive phosphors, when struck with their corresponding colored lights, do likewise. A red-sensitive phosphor is not sensitive to blue or green, and therefore will not glow when struck with either of those two colors. Likewise for the green and blue phosphors. TV is additive, and operates in much the same way as any additive color process.

Let us deal with the additive primaries. Red, green, and blue light, when combined in equal amounts, produce white light. *All white light consists of red, green, and blue.* White light, falling upon a white object, is reflected back to the viewer as white light. White light falling upon a red object is reflected back as red, because all the blue and green are absorbed or *subtracted.* Pure *red* light falling on a pure *blue* object is also absorbed—the viewer perceives *black.*

Now, let's deal with another group of colors: the complementary or *subtractive* colors—cyan, magenta, and yellow. As the chart on page 137 demonstrates, cyan light is made up of blue and green light, magenta light is made up of blue and red light, and yellow light is made up of green and red light. In the case of magenta light striking a blue object, the resultant reflected color will be blue, as the red portion of the magenta light will be absorbed, or subtracted. Carried a step further, white light striking a magenta object will reflect back only its blue and red portion—the green will be subtracted as there is no green in magenta. Replace subtractive filters for the above objects and you have the elements for the subtractive system of color photography upon which all modern color films are based. For example, green

light will pass through a cyan filter because cyan contains green. Green light will also pass through a yellow filter for the same reason, but will not pass through a magenta filter, as there is a total lack of green in magenta. Magenta is therefore minus green. Yellow is minus blue. Cyan is minus red.

In 1935, Kodachrome film, the first multilayered, *subtractive* color film, was introduced. Its inventors were two independent researchers named Leopold Mannes and Leopold Godowsky.

Kodachrome is a multilayered film that, when exposed in the camera, is still essentially a black and white material. However, each of three layers is sensitive to a different colored light. The top layer is sensitive only to blue,* the next layer only to green, and the last layer only to red. Upon exposure, each layer is affected only by that color it is sensitive to. During development, the photographic negative is reversed to a positive, and after the black silver is bleached out, it is replaced in each layer by the dye of a subtractive color complementary to the original sensitivity. The blue-sensitive layer is dyed yellow, the green-sensitive layer is dyed magenta, and the red-sensitive layer is dyed cyan. When viewed through transmitted light, the proper filtration within the film itself produces a brilliant, full-color transparency far superior in color saturation, contrast, and sharpness to anything that came before. The results are stunning, with a range of subtleties that rivals nature's.

Kodachrome, always the standard by which all other color films are judged, requires complex processing procedures and to this day is processed only by Kodak and a few others. In 1942 Ansco (now GAF) introduced Ansco-Color film, which because of incorporated dye-couplers, could be processed by the photographer himself, or by small, independently operated labs. This was followed quickly by Kodak's Ektachrome and a host of others.

* Directly under the blue-sensitive layer is a layer of yellow dye used to filter out (absorb) the blue portion of the spectrum in order to keep it from striking the other layers which have a residual blue sensitivity. The yellow dye is dissolved during processing.

In 1941, Kodak produced Kodacolor, a negative color film, specifically manufactured for printmaking. It was formulated much like Kodachrome, except for the reversal steps in the processing. The final result is a negative in which even the colors are reversed to their complements. This was followed by Ektacolor, another negative film, which like Ektachrome, could be processed by the user.

Chapter Six

FILM FUNCTION

Today there are great differences in the various types of film, both black and white and color, available in the 35mm gauge. These differences are determined by physical and chemical characteristics and their relation to light sensitivity (speed), graininess, color saturation, contrast, acutance, and maximum density.

Film Speed (Black and White and Color)

Films of different types vary as to their sensitivity to light. The degree of sensitivity is referred to as film speed and graded according to a numerical series of "ASA ratings." * *The higher the ASA rating, the more sensitive the film to light.* All 35mm film is so rated. Exposure meters (both built-in and handheld) must be set according to the proper ASA before they are used. ASA data is packaged with the film, in most cases actually printed on the film cartridge itself.

Films with high ASA ratings call for less exposure than films with low ASA ratings. It is a ratio that works out to one-stop exposure increase each time the ASA rating is halved, or one-stop decrease each time the rating is doubled. For example, if you

* European film is calibrated in DIN (although ASA ratings are used throughout the world).

had two cameras, one loaded with Fugicolor N-100, rated at ASA-100, and the other loaded with Ilford Pan-F, rated at ASA-50, the exposure reading for the two cameras would be one stop apart. Let's say that the proper exposure for the Fugicolor worked out to 1/250 sec. at $f/8$; in that case, correct exposure for the Pan-F would be one stop less: 1/250 sec. at $f/5.6$, or 1/125 sec. at $f/8$.

Film sensitivity, or speed, varies tremendously, all the way from Kodachrome 25, at ASA-25, to Kodak 2475 Recording Film, rated as high as E.I. 3200! *

Of course, everything has to be paid for. In photography, just as in real life, you get nothing for nothing. The price paid for high-speed film is loss of quality. Generally, the faster, more light-sensitive the film, the grainier it will be. It is also likely to be less sharp, and in some cases overly contrasty.

As a demonstration of the vast range of film speeds: in a situation where the exposure for Kodak Panatomic-X (ASA-32) would be $f/2$ at 1/60 sec., the proper exposure for Kodak 2475 Recording Film (E.I. 3200) would be $f/19$ at 1/60 sec.! Kodak 2475 film (at this E.I.) works out to be 100X more light sensitive than Panatomic-X (ASA-3200 ÷ ASA-32 = 100).

The above example is admittedly an extreme one, as the Recording Film is a specialized material. A more realistic example would be to compare Pan-X with Tri-X, a standard black and white emulsion (film) rated as ASA-400. The ratio in this case would be roughly 13X.

Grain (Black and White and Color)

Grain, to many photographers, has always been a bugaboo. It is no more nor less than the clumps of silver visible in the

* The term "exposure- index" (E.I.) is applied when, for example, Tri-X film is exposed and/or processed to a speed higher or lower than that of its normal ASA rating. E.I. is also used by the manufacturer in situations where a given film has no optimum sensitivity, as is the case with 2475.

emulsion of any film. Together, these particles form the image on the film itself, but when *visible* on a print or projection screen, at normal viewing distances (to the naked eye), the results are said to be "grainy." Of course, evaluation of grain is a purely subjective matter.

The size or "amount" of grain is determined by the type film used, the exposure, and film-processing procedures. Overexposure or overdevelopment of the film can cause extreme graininess. Accidental exposure to light or film that is overaged or that has been stored badly can result in an overall "fog," also a cause of graininess. Large expanses of medium gray on the negative are more likely to reveal grain than are areas broken up with a variety of tones, or highlights or shadows.

Most important of all, "grain" is a natural ingredient of all film—without it there would be no image. What concerns us is the size, or obviousness, of grain. It follows that the smaller the negative size, the more visible the grain because of the large magnification needed for standard-sized enlargements, reproductions, or projections. A 16" x 20" blowup from a 4" x 5" negative is obviously going to suffer far less from graininess than the same-size enlargement from a 1½-inch 35mm negative.

As a general rule, the higher the ASA rating, or E.I. assigned to a film style type, the grainier the results. It's a kind of payment for the extra sensitivity or speed. There's no way around it. *The higher the film speed, the granier the results.*

There are some beginning and amateur photographers who go into deep fits of depression over the slightest indication of grain. This, despite the fact that the image they are observing with such distaste could have been acquired in no other way. To purists such as these, I recommend switching to a larger format photographic system, 4" x 5" view cameras, or, if they aren't quite that pure, the Hasselblad or Rollie or some other 2¼-inch system. They will, of course, give up the versatility of the 35mm camera in the exchange, but their grain problems will be substantially reduced.

Grain.

This author's personal feeling concerning the problem is that "grain" is a natural function of the 35mm process. *It's there, live with it.* It is an inherent part of 35mm photography and in many cases actually enhances the final image. There are times when grain is actually an aesthetic tool, to be used much as a pointillist painter might use it. For grain, just as it can be minimized, can also be maximized, even exaggerated. A fast film when over-developed will certainly give it to you.

Aesthetically, there are two types of grain. One type appears tight and actually granular, each speck of it seemingly individually defined. The other type, to be avoided when possible, is "mushy," with an appearance similar to that of oatmeal. Sharply defined grain has the tendency to delineate the image, lending

it an illusion of sharpness. "Mushy" grain, on the other hand, has the opposite effect. Experimentation in finding the right film-processing combination is decisive in this respect.

It must be added that when making enlargements from grainy negatives, the grain be sharply focused on the paper from corner to corner.

All is not lost, however. If the photographer is willing to settle for a lower film speed, or if the light levels, etc., do not require a fast film, he can *approach* "perfection" with the 35mm image. There are a few films available that will give him almost grainless results, along with incredible sharpness, providing they are processed properly. A few of these are:

<div align="center">

BLACK AND WHITE

Kodak Panatomic-X (ASA-32)

Ilford Pan-F (ASA-50)

H&W Control VTE Ultra Pan (E.I. 16)

H&W Control VTE P Pan (E.I. 50)

COLOR

Kodak Kodachrome 25 (ASA-25)

Kodak Kodachrome II, Type A (ASA-40T*)

</div>

Acutance and Sharpness (Black and White and Color)

Acutance relates to edge sharpness or the ability of a film to define a dividing line between two tones. Sharpness, or resolving power, relates to the degree of internal definition.

Contrast (Black and White and Color)

The extent to which any film differentiates between light and dark tones determines its degree of contrast. A film, either black

* The "T" stands for *tungsten*, an indication that the film is color balanced for artificial light.

and white or color, that is deficient in reproducing the middle tones of gray is considered a high-contrast film. A film that is lacking somehow in blacks and whites and consists mainly of middle grays is considered to be of low contrast. (Both of these phenomena can be simulated on a TV set by manipulating the contrast control.)

Color Saturation (Color Film)

Color saturation is determined by the degree of color intensity inherent in the film. Some color films tend toward a brilliant, flamboyant, larger-than-life quality, others, toward a pastel, subdued quality. Saturation does not necessarily relate to contrast.

Maximum Density ("D-Max") (Color)

D-max relates to the degree of density in the least exposed areas of the film. The opacity, or blackness, of the black areas of the processed film is quite important in terms of image quality. A low or translucent maximum density indicates that the film has been processed incorrectly, or that it is old (dated), or that it has been stored improperly, or that it has been fogged by errant light or chemicals, or that it has been improperly reversed during processing, or that there has been a temporary malfunction in the manufacturing process, or that it is just plain old lousy film. Any of the above can be responsible for low D-max. A quick eyeball check can determine, at least roughly, the degree of D-max. If the black areas of the film, when projected or inspected under magnification, seem to lack density, if it seems as if you can *see through* the heavy shadow areas on the transparency, or if they have a sickly green or brownish cast—then the D-max is decidedly low. The film has been robbed of essential contrast—it is sick film.

Another major source of D-max loss is "pushing," to be discussed in Chapter Sixteen.

As mentioned earlier, in terms of film choice, everything has to be paid for in one way or another. For example, if you want to shoot with a highly saturated, relatively grainless color film with good contrast, you have to pay for it with lack of film speed. Such high-quality, but low-speed transparency films are: Agfachrome CT-18 (ASA-50), GAF-64 (ASA-64), Kodachrome 25 (ASA-25), Kodachrome, Type A (ASA-40T), Kodachrome 64 (ASA-64), Kodak Ektachrome-X (ASA-64).

On the other hand, if speed is what you're looking for, you usually have to pay for it with reduced contrast, reduced color saturation, reduced sharpness, and increased grain. The color transparency films that manage to make these compromises gracefully are Kodak High Speed Ektachrome (ASA-160), Kodak High Speed Ektachrome, Type B (ASA-125T), GAF-200 Slide Film (ASA-200), Fujichrome R-100 (ASA-100). A color transparency film that *doesn't make it so gracefully* is GAF-500 (ASA-500). Of course, allowances have to be made for this film due to its incredibly high speed and its special, large, but surprisingly tight grain can be a useful aesthetic tool.

Kodachrome 25 (and Kodachrome, Type A) sets the standard to which all else is compared. It has the highest acutance and resolving power (sharpness) of any color film available. It is virtually grainless. Because of processing procedures, it is highly standardized and seldom varies in quality. It is highly resistant to color shifts due to bad storage conditions, heat, humidity, age. Kodachrome was the first of the modern multilayered color transparency films, and after less than a half-dozen modifications since its inception in the early thirties, it is still the champ.

Both personal taste and specific requirements play a large part in film choice. As mentioned previously, there are highly color-saturated films that result in brilliant, often exaggerated colors. There are color films with relatively low saturation which are capable of producing soft, lovely, pastel-like shades. There are high-contrast and low-contrast films, and emulsions with coarse grain patterns. There are color films that reproduce colors differently—no two brands or types treat reds and yellows alike. There

are films that respond with the brilliant greens of foliage and films that accentuate the blue in skylight shadow areas. All these differences can play an aesthetic role in the final product. Therefore, since taste and specific need play such heavy parts, personal experimentation is the only means of acquiring the data necessary to make these choices.

Tungsten Film (Color Transparency)

There are two basic kinds of color transparency film available, *daylight* and *tungsten*. Daylight film has an emulsion that is *balanced* for the full normal spectrum of sunlight, while tungsten film is balanced for the *warmer,* orange-reddish color of incandescent or tungsten light. The human eye adjusts for these two extremes in what is known as "color temperature," but such automatic corrections are beyond the ability (currently) of color film. Therefore, the photographer is obliged to use a color transparency film that has a color sensitivity in balance with the prevailing light source, or to use a correction filter to modify the color temperature of the light before it passes through the lens and onto the film. An overall blue shift, or cast, is the result of using unfiltered tungsten film (Type A or B) in daylight. A heavy red-orange shift (cast) is the result of using daylight films under incadendescent lights.

At this writing there are only two indoor, or tungsten, films available in the western world: Kodachrome-A (ASA-40) and Kodak High Speed Ektachrome, Type B (ASA-125). Kodachrome-A is a superb, almost grainless emulsion, with high color saturation and sharpness. It is extremely useful in studio situations where there is an abundance of incandescent light, or where the camera can be mounted on a tripod so that long exposures are possible—for example, for the photography of art objects, paintings, etc., where the excellent color fidelity of Kodachrome is a decided advantage. Kodachrome-A is just too slow to use for general hand-held indoor photography, sporting events, etc.

The only other tungsten emulsion, High Speed Ektachrome,

Type B (known as HSB), is a marvelous compromise. Eastman Kodak, down through the years, has made quiet, unannounced improvements in this emulsion, along with its sister film, High Speed Ektachrome (daylight). Its contrast can best be described as "low-medium," and it has a fair amount of saturation and a surprisingly tight grain pattern for such a fast film. It seems to improve year by year, which is encouraging, as it is the only color film of any type that has the speed necessary to shoot in available tungsten light. It is HSB or nothing, for indoor candids, arena sports, or any other indoor photography that requires hand-held cameras where the incandescent tungsten light is less than 32 footcandles* ($f/1.4$, $1/60$ sec. at ASA-125).

Negative Color Film

Negative color film was developed primarily for the making of direct color prints. Prints *can* be made directly from transparency film, but despite recent improvements in processing and new printing papers, direct prints made from original color negatives are far superior.† Though at this writing there are rumors of a new Kodak negative color film to be rated at ASA-400, there is currently available no negative film rated over ASA-100.

Negative color films generally have a greater exposure latitude than transparency films. This means not only that they approach

* A technical measurement referring to light intensity.

† We speak of *direct prints,* i.e., prints made directly from the negative or the positive transparency onto printing material, a process that has been simplified tremendously over the past decade. Negative-to-positive systems include Type C, Ektachrome 37, GAF, Type 7100, etc. Positive-to-positive systems, such as Cibachrome and Ektaprint leave much to be desired. However, *internegatives* can be made from positive transparencies and these printed as original negatives. The results are excellent, sometimes rivaling those of actual original negatives (despite the contrast increase).

The best prints of all are made by the dye transfer method, a system that makes use of color separations from positive transparencies, or negatives. Dye transfer is expensive and time consuming compared to direct printing methods. Carbro, the most exquisite of all color print methods, is unfortunately a dying art.

black and white film in terms of extended contrast range, but that they will tolerate a greater range of overexposure and underexposure.

It is possible to make transparencies from color negatives yourself, and also through independent labs, or in some cases through the laboratory services of the manufacturers. Blown-up transparencies up to and beyond 8″ x 10″ are also possible.

Negative color films are not generally used by professional photographers involved with the print media. These films are more suited to situations where photographic prints are the primary product.

Reciprocity Failure (Black and White and Color)

Reciprocity failure is the inability of most emulsions to sustain overly long or overly short (strobe) exposure times. For example, High Speed Ektachrome (daylight), when exposed for longer than 1 sec., loses a good deal of its light sensitivity and requires an increase of one full stop exposure. Thus, if you were using an exposure of $f/2.8$ and 1 sec., you would have to increase your aperture to $f/2$. Data sheets, packed with all film types, sometimes give reciprocity data. In some cases, color-correction filters are also necessary.*

Film Care

All photographic emulsions are subject to deterioration due to heat, humidity, and age. Film boxes are labeled with an expiration date. Pay heed. Film that has been improperly stored or otherwise mishandled is likely to lose speed and contrast through fog, etc. Color film will do likewise, developing a low D-max and obvious color shift. Color film is more susceptible to this kind of damage than is black and white.

* Reciprocity tables can be found in Appendix Two.

Some General Rules to Follow

1. Film that is not to be used for a few days should be stored in the refrigerator in its unopened box. If you are storing film that has been removed from its carton and can, make sure it is in an airtight container. (A good idea is to wrap the rolls you're storing in two Baggies, one inside the other, and then in a sealed jar or bottle.)

2. Your refrigerator freezer is a good storage place for
 A. Film that is nearing its expiration date and is not going to be used immediately.
 B. Film that has been exposed and for some reason is not going to be processed for a few days or more.
 C. Film that you expect to keep beyond its expiration date.
 D. Any film that is not going to be used within a month.

3. Exposed film should be processed as soon as possible. The undeveloped, latent image is an ephemeral thing indeed. (When removing film from the refrigerator, allow it to return to room temperature before unpacking it—about 1½ hours for the refrigerator or 3 hours for the freezer.)

4. Do not store film in the glove compartment or the trunk of a car, particularly in the summer. The best way to travel with film in hot weather is to keep it in a picnic cooler along with cans of silica gel (available from your local camera or hardware store) and cans of frozen coolant (hardware or supermarket). The silica gel, incidentally, absorbs moisture . . . which leads me to the warning about *not* storing film with *wet* ice.

5. When going through baggage inspection before that flight to Wichita or Brisbane, insist that whatever it is you're storing your film in be visually inspected. Despite what they tell you about the X-ray machine being safe for film, insist and keep insisting. Remember, you're going to be coming back the same way—with *exposed film*—that makes it a double shot of X ray. And if you have to make connec-

tions, that's another double shot! Actually, one is bad enough. It strikes me that exposing your film to X rays is about on the same level as drawing to an inside straight —you might get away with it.

If you are shy about demanding a visual check instead of X-ray, your camera store has small lead bags into which you can stuff as many as fifteen unboxed rolls of film. The bags are safe from moderate X-ray of the airport type. The problem is that usually (not always), when the machine registers a black blob in your bag, the powers that be will ask for a visual check anyway . . . but it's worth the shot. (Though I've been told three hundred times or so that they don't X-ray checked baggage, I'm still suspicious. I carry my film on board, where I *know* what's happening to it.)

On the film box, somewhere near the expiration date, you will note a coded number. This is the *emulsion number* of a particular batch of film. It means that any film bearing this number will have exactly the same general characteristics. Yes, a particular film type will vary somewhat from batch to batch. Professionals usually test and then buy up film of one particular batch and store it. This ensures a continuity of result. However, for the most part, emulsion batches differ very little, in many cases imperceptibly. Though every now and then . . .

Chapter Seven

THE EXPOSURE METER

There are two kinds of exposure meters: (1) reflected-light meters that measure the amount of light being *reflected from* the subject and (2) incident-light meters that measure the amount of light *falling onto* the subject.

The two types of meters, despite the fact that they measure different kinds of light, have something in common. They use one of three different types of photoelectric cells.*

Photoelectric Cells

Selenium Cell

A photosensitive device that requires no external power. Essentially it transforms light directly into electric current which is then used to displace a needle on the dial in direct proportion to the amount of current generated. Its advantages are durability, simplicity of construction, dependability, low initial cost, and the greatest degree of accuracy. And, of course, selenium cell meters do not require batteries. These meters have only one

*The Spectra Combi 500 makes use of both a selenium and a CDS cell, allowing the photographer the option of which to use.

disadvantage: low sensitivity (when compared with the two other types). For example, the Sekonic Studio Deluxe (incident) has a minimum sensitivity down to roughly $f/1.4$ at $1/8$ sec. (ASA-64) or about 8 footcandles.* This degree of sensitivity is more than sufficient for most shooting situations, but it won't do for more exotic readings such as moonlit subjects, coal mines, or the insides of hats.

Cadmium Sulfide Cell (CDS)

A highly sensitive photocell that requires an electrical current, which the cell modulates according to the amount of light falling on it. Most of the built-in BTL camera meters make use of the CDS cell. The main advantage of the CDS cell is its high degree of sensitivity. For example, the Metrastar (reflected-incident) meter will read down to $f/1.4$ at 8 sec. (ASA-64)! Since moderately low light levels are read somewhere near the *center* of the "low" scale, instead of at the *low end,* where the scale itself is compressed, a good degree of precision is assured in this range with most CDS meters. Another advantage to the CDS cell is that its circuitry lends itself to many applications denied the simple selenium cell. For instance, Minolta makes two meters in which it is not necessary to match needles manually, as the scale itself is powered by a servomotor, thus allowing the photographer to operate the meter with only one hand. (Any professional photographer will attest to the fact that two hands are not enough with which to operate efficiently in his chosen craft ... it is general knowledge in the trade that three hands would be optimum.†

The disadvantages of the CDS cell are: (1) Decreased efficiency in cold weather due to lack of battery tolerance. (2) Ex-

* All Spectra incident-light meters possess selenium cells that are at least a few stops more sensitive than this. Spectra is the almost universal choice of professional cinematographers.
† The first manufacturer who puts on the market a "one-handed" camera will reap unimaginable benefits!

tremely slow recovery after being exposed to brilliant light. (You have to wait, sometimes as long as a minute, for the meter to recover so that it can read a lower light level.) (3) The CDS cell lacks sensitivity to some colors, and therefore will produce incorrect results when reading through certain filters. This is a problem more often encountered with BTL meters in situations where the photographer might have a filter attached to the camera lens.

Silicon Blue Cell

A more recent development, the silicon blue cell makes up for all the deficiencies of the CDS cell except cold weather reliability. At temperatures near freezing the cell loses a good deal of its sensitivity. This, however, as in the case of the CDS cell, is a function of the battery, and as battery technology improves, the problem will most certainly be resolved. Silicon blue rivals the selenium cell in its accuracy and is at least as sensitive as the CDS cell. At this writing it is being used as a BTL meter in a small number of cameras and just a few handheld meters. The silicon blue cell represents the future of exposure meter technology.

Exposure Meter Scales

The exposure meter scale operates as a kind of slide rule, with two inputs: light measurement and ASA-exposure index setting. Once these two factors have been set, the meter readout will present the photographer with a series of f/stop-shutter-speed combinations, from which he can choose the one most suitable for the matter at hand. As has been explained earlier, any of the combinations will result in a correct exposure. Other data in the readout might include, depending on the brand of meter, a footcandle reading, an E.V. reading (each series of f/stop-shutter-speed combinations is assigned an Exposure Value number, from 1 to 20—see charts, pages 112-13), a cine scale that

gives motion-picture readings at various cranking speeds, a DIN readout (actually an alternate input corresponding to the ASA input but which can be used to compare European DIN ratings with ASA ratings). Of course, BTL meter readouts refer only to exposure in terms of f/stop-shutter speed; more than that would clutter up the viewfinder.

Many reflected-light meters also have a sliding receptor which can convert them into incident-light meters. For the most part, such conversions work quite well. However, incident-light meters, which use an accessory device to convert them to reflected-light-meter functions are not quite so efficient. (One exception to this is the Minolta Autometer, which supplies an accessory, narrow-angle reflected-light receptor, plus such goodies as a ground-glass probe and even an enlarger metering head.)

Reflected-Light Meters

In discussing reflected-light meters it is necessary first to deal with those that are built into practically every 35mm reflex manufactured today plus those so cunningly incorporated in the Leica M5 and CL.

Some BTL meters are touted by their manufacturers as being full-area, or averaging, meters, meaning that the entire area you see in the finder is being read by the meter and averaged out. Other BTL meters contend to be "center weighted," indicating that the majority of the meter's sensitivity will be toward the center of the viewing screen. Then there are BTL meters that insist they are bottom weighted, or top weighted. Minolta, on some of its cameras, uses a BTL meter called CLC, which makes use of contrast compensation circuitry using two cells, which compare the top half of the frame with the bottom half, split the difference, and then add exposure if the two are disparate. This is to provide enough extra exposure to compensate for excess contrast in the scene, so that shadows will not block up. A dubious idea, in that, when shooting color, there is a very slight possibility that

it may cause you to overexpose the highlights, a far greater sin than blocking up shadows. Fortunately, the CLC feature has minimal effect, at best—or worst—and with a little experience or foreknowledge can be handled very readily. Nevertheless, my point is that though most of the abovementioned meter types have a high degree of accuracy, they tend to treat the photographer as a kind of ignoramus who is better off not knowing exactly what the meter is doing! The center-, top- or bottom-weighted meters are generally what they are touted to be, but there is nothing in the viewfinder to indicate *exactly what portion of the frame is being weighted, and how much.* The Konica camera, for example, reads a different size area with each lens! Even the so-called full-area, averaging meters have varying sensitivity across the field, and are therefore *not* full area meters.

As a photographer, I feel that I myself should be in control— and secure in the fact that when I point my camera at a subject I know exactly what area the meter is reading.

There are three cameras that perform this function beautifully: the Leicaflex, the Leica M5, and the Canon F-1, which have in their finders a prescribed area, indicating precisely the area of meter sensitivity. When you place the prescribed center rectangle in the Canon finder (or the even smaller circle in the Leicaflex finder) over the subject, you *know* exactly what the meter is reading. Nothing is going on behind your back in the metering department.

Even that problem, however, can be dealt with. The following test can help you determine the metering pattern within the finder of your camera: first, set up a 40- to 60-watt light bulb and turn all other lights off. With a normal lens on your camera stand about 15 feet away from the light. Set ASA at about 600 and your diaphragm at about $f/8$ and sight through the camera. Start with the lit bulb in the upper-left-hand corner of the frame and slowly pan to the right, watching your meter readout as you go. When you get all the way over to the right, raise the camera just a smidgen and pan slowly to the left. Keep this up, as if

you were eating an ear of corn, or reading a book, until you've completed the survey in one of the bottom corners of the frame. If you were watching your meter needle or diodes carefully, you will have noted the points in the finder that registered the greatest sensitivity. Make note, as this knowledge will help you immensely in many situations where metering is critical. You will know in the future that, when you superimpose the most sensitive metering area on the subject, you will be getting an optimum reading— instead of an inflated reading of the white tiled floor he's standing on.

The standard for all reflected-light meters, both BTL and hand-held, is a 40% gray with a reflectance factor of 18%. What this means is that a reflected-light meter "assumes" that what it is reacting to or reading is a scene that is reflecting 18% of the light that is falling on it. In practical terms, this means that a reflected-light meter will *always* read out an exposure calculated to produce the equivalent of a 40% overall-gray integrated tone on the film.

To put it more simply, if when photographing a white wall, we accept the reading of a reflected meter as being correct, the results on the film will be 40% gray. If (theoretically in this case) we photograph a black wall, using the suggested reading of a reflected-light meter, the resultant photograph *will also be equal to a 40% gray.*

Reflected-light meters assume that the entire world and all that is in it reflects only 18% of whatever light falls on it and they act accordingly. The meter does not differentiate, it calculates an average out of what is placed in front of it. Fortunately, in real life, much of the world does reflect 18%. The *average* landscape, for example, comes close to that ideal, as does a dark-skinned Caucasian or a light-skinned Black.

What the meter *sees* and how it reacts can be explained best by asking the reader to imagine a typical sunny landscape, painted in oils. While the paint is still wet, we will ask the artist to smear all the colors on the canvas together until they are thor-

oughly blended, and become one continuous tone representative of all the colors, tonal gradations, highlights, and shadows of the original painting. One continuous tone—exactly as the reflected-light meter sees the world.

If this integrated average tone is significantly lighter than a 40% gray, it will then reflect more than 18% and the resultant photograph will be underexposed. If, on the other hand, it is darker than a 40% gray, it will reflect less than 18%, and the resultant photograph will be overexposed.

Fortunately, most *average* subjects fall fairly close to this 18% ideal. If we take a typical outdoor or indoor scene involving people under average circumstances, reflectance will be close to the 18% the meter is based on. The results will more or less match the original scene. However, what happens when we execute a medium or long shot of a skier against bright white snow? The meter will perceive this scene in its usually mindless way, as an integrated, very light shade of gray rather than as a relatively dark object against a dominating, stark-white background. The meter will call for minimal exposure, the diaphragm will be stopped down accordingly (or the shutter speed increased), and our skier will be underexposed considerably, resulting in an almost total silhouette against gray snow. The same applies in varying degrees to subjects in beach scenes, seascapes, and scenes dominated by large areas of brilliant, slightly overcast white sky.

There are times, of course, when you might *want* your subject to be silhouetted against snow, or water, or beach, but the decision should be yours rather than the arbitrary choice of an exposure meter.

Another problem involves metering bright objects against black backgrounds with reflected or BTL meters. A good example of this is the spotlighted theatrical performer. Unless you can approach the stage to take a closeup reading, you are faced with the problem of dealing with the usually extensive black area surrounding the entertainer. Neither a conventional handheld reflected light meter nor the meter in your camera is going to be

of much help from the tenth row, from which your meter will read the predominant black and lead you to overexposure. The exception to this could be the use of the metering system of the Leicaflex or Leica M5, which reads a very narrow angle (especially if there is a long lens attached). These cameras possess true *spot meters*.

Semispot meters may be found on such cameras as the Canon FTB and F-1, the Miranda EE, and a few others. They read a somewhat wider angle, and would require you to move closer to the subject than would the Leicas, but they are a definite convenience in situations of this type.

There are many ways to deal with the above exposure problems, and they will be gone into extensively in a later chapter.

The Incident-Light Meter

Outside of the fact that handheld, reflected-light meters are more efficient (sensitive) than BTL meters, there is very little difference between them. In fact, unless the photographer intends to work extensively in dim light, where the extra sensitivity of the handheld (CDS or silicon) *reflected-light* meter is beneficial, such meters are somewhat superfluous, as the behind-the-lens, built-in camera meter is quite satisfactory as far as it goes.

The incident-light meter is a handheld exposure meter based on an entirely different principle than the reflected-light meter. The incident-light meter, instead of "reading" the light being reflected from the subject, *reads the amount of light that actually falls on the subject*. Unlike the reflected-light meter (and that includes the BTL meter in your camera), it matters not what color or shade the subject happens to be. In the same light, a black object will elicit the same reading as a white object. The incident-light meter is not concerned with matching a 40% gray (18% reflectance) against the subject.

An incident-light meter (or a reflected meter convertible to incident-light readings) measures the amount of light that falls

on a translucent white plastic dome, shaped much like a half Ping-Pong ball. It measures all the light striking the dome, or *photosphere,* from 180° in any direction. The inside of the photosphere, which is the area being read by the light-sensitive photocell, is in a sense a model of the real world. The frontal area of any three-dimensional object in the "real world" is also lit by the light striking it from all angles up to and including 180°. (It obviously cannot be lit frontally by light striking it from behind and thus is limited to 180°, just as is the photosphere on the incident-light meter.)

To use an incident-light meter, you don't point it at the subject. Rather you point it *from the subject toward the camera.* The photosphere on the incident-light meter is a model of the subject, and we want *the same light that is falling on the subject to fall on the photosphere.*

It is not always necessary, when using an incident-light meter, to stroll over to the subject and read from its position, nor is it necessary to hike a mile and a half into the landscape you're shooting, in order to get a reading. All that is necessary is *for the meter to be in the same light as the subject.* You can in many cases accomplish this from the camera position, on which, for example, the same sun is shining that is shining on your subject, your landscape, or the tank battle that you also might not care to be in the middle of. All that is required is to point the meter in the proper direction.

I favor the use of the incident-light meter above all others, simply because it measures incident light rather than reflectance, and therefore leaves the photographer the option of interpretation.* Going back to the earlier reading of the skier, an incident-light reading dealt with earlier, would come up with an exposure which would render the skier in normal tones and the snow as

* The exception to this recommendation is the use of the reflected-light meter for interpreting tonality when using the zone system, discussed elsewhere in this book.

white. If the photographer decides that he'd prefer a silhouette, then it is a simple matter to underexpose a stop or so—but it remains his prerogative, not the meter's.

The Spot Meter

The hand held spot meter is a meter that reads a very narrow angle. Currently, there are three on the market: the Soligar, the Pentax, and the Minolta. Of the three, the Minolta Auto-Spot is by far the most sophisticated and is used extensively in motion-picture and TV work. The Auto-Spot reads an area of 1°, which is viewed through a reflex viewfinder encompassing an 8° field of view. In the center of this self-contained reflex viewfinder is a small circle that delineates the 1° area being measured. The viewfinder display also contains pertinent data regarding ASA, f/stops, shutter speeds, etc. Since the scales in the viewfinder are servoactuated, requiring no needle watching, etc., the meter, like the Minolta Autometer, is one-handed. The Auto-Spot is beyond a doubt the quintessential spot meter, and it is priced accordingly. The Soligar and the Pentax spot meters also read a 1° spot, through reflex finders, and though not as sophisticated, are somewhat cheaper and equally reliable.

The handheld 1° spot meter is invaluable in those situations in which the subject is remote and unapproachable. It is a perfect tool for theatrical and indoor sport activities such as concerts, circuses, boxing matches, or anything that exists at a distance, exclusively in its own lighting.

Its magnification ratio is 24X, equal to some celestial telescopes. Therefore, the 1° spot meter reads a minuscule area of the subject and must be aimed with extreme care, making sure to spot an area on the subject that approaches the standard 40% gray. The spot meter is essentially a reflected-light meter and therefore, like all its cousins, is programmed to an 18% reflectance.

Learn the geography of your camera by touch. All the controls should come readily to hand. In which direction do lenses focus toward infinity? In which direction do you have to turn the shutter-speed dial to obtain a lower speed—the diaphragm control ring? Get comfortable with your camera, get to know it intimately; it can be a true extension of your eye.

Part Two

CAMERA TECHNIQUES

Chapter Eight

FOCUSING

Just as the eye must focus on its target, so must the camera. The eye, of course, accomplishes its purpose in an unconscious manner. The camera, on the other hand, must be focused consciously. However, with practice, focusing a camera can become a kind of second nature, almost an automatic action. The focusing collar is turned rapidly until the eye perceives the emerging point of focus. The turning action slows, until finally focus seems to be achieved—then goes slightly beyond and slowly back, surer now, to the point of focus. The idea is to dispense with the uncertainty of searching, back and forth, in and out, for the elusive focus point like a quartering beagle searching for his own scent. Practice makes perfect.

Most focusing rings or collars turn left (counterclockwise) to focus at far objects and right (clockwise) to focus at near objects. Left goes inward, right goes outward—the first thing to learn to do instinctively.

The next thing to learn is what "in focus" looks like. For this purpose, dispense temporarily with the focusing aids in the center of the reflex viewfinder and practice focusing on the ground glass. Use a well-defined target such as a candle flame from about 7 feet, starting with your normal lens at infinity. When you reach the point where you can establish focus with a reflex camera in less than 5 sec., you're in business.

With a rangefinder camera, you should be able to do it in three seconds. As time goes on, you'll find you're beating your own record by as much as 50%. The object is not necessarily speed, but rather decisiveness.

With reflex cameras, the longer the lens, the easier it is to focus. Telephoto lenses seem to pop into focus quite readily, particularly when large images are superimposed over out-of-focus areas. Wide-angle lenses, on the other hand, have a tendency to appear to be in focus all the time, particularly at distances exceeding 10 feet.

The two Leica rangefinder cameras focus handily with any lens, requiring, of course, somewhat more care with lenses of the longer focal lengths. An interesting bonus, not realized by many Leica users, is that the top and bottom borders of its rangefinder patch can be used as a split-image rangefinder, giving the photographer a choice of either split-image or coincident-type focusing.

Now to the central focusing aids, usually clustered in the center of reflex camera viewfinder screens.

Focusing Aids

Split-Image Spot

This is a small circular area containing a horizontal split. (On the Alpa Reflex it is a diagonal.) Essentially this is a *split-image rangefinder*. A vertical line on the subject will appear in the split-image circle as a broken line when out of focus. When the lens is focused, the line is unbroken. To use the split-image focusing aid, you must find a vertical or near vertical somewhere in the area of desired sharpness. It can be a nose, an arm, a leg, a structural member, the sharp edge or side of anything you want to be in focus. The split-image-rangefinder focusing aid in the center of many reflex focusing screens is a great help when using wide-angle lenses. However, when used with lenses longer than 50mm, its accuracy becomes questionable.

Microprism Circle (or Collar)

This also is a circular area, usually larger, and in many cases surrounding, the split-image spot in the center of the reflex finder. The microprism focusing aid sometimes breaks up the image to such an extent that when out of focus it seems (to some eyes) to actually "shimmer," as if it were somehow alive. When the image reconstitutes itself and stops shimmering, the lens is in focus. Microprism focusing works best with lenses under 100mm focal length (except for some types made specifically for long lenses).

Coarse-Ground-Glass Circle (or Collar)

Coarse ground glass breaks up the out-of-focus image to a greater extent than does fine ground glass. As a focusing aid it works well with all focal length lenses and is usually supplied as a collar around a split-image spot. Unfortunately, it seems to be going out of favor and is being replaced by many manufacturers with a central microprism spot or collar.

Focusing aids, as mentioned above, are clustered in a circle in the center of the viewfinder screen. Very popular these days is a split-image-rangefinder spot surrounded by a microprism collar. The remainder or major portion of the finder is ground glass usually overlaid with a Fresnel screen which supplies even illumination across the entire viewfinder. (Without the Fresnel screen, the corners of the finder would tend to darken.) Many professional photographers prefer a plain ground glass, with no Fresnel screen or focusing aids of any kind. They are purists, and argue against extraneous "garbage" getting between them and accurate focusing. I am not quite so pure, and prefer a split-image spot (for use with extreme wide-angle lenses) and a fine Fresnel. My favorite screen is Nikon's Type-L. (See diagram pages 38-9.)

When deciding on a reflex camera do not get carried away with arguments and sales pitches about *brilliant* viewfinders. It is true that some cameras have more brilliant finder screens than others. However, "brilliance" carries a penalty—*cameras with such screens are harder to focus.* As has already been stated, the

coarser the ground glass, the more readily it breaks up out-of-focus images. Coarse ground glass is not nearly so bright as fine ground glass, and the finer the ground glass, the more difficult to focus on it. (Usually resulting in eyestrain.) In fact, some cameras have ground glass so fine that they approach an aerial image in quality, and aerial images will focus nothing this side of a 1000mm lens. Most manufacturers compromise between finder brilliance and ease of focus.

Cameras with interchangeable prisms (and a few without) offer the option of interchangeable focusing screens. Settle on the one that works best for you as a general, all-purpose screen for the majority of your lenses. Additional screens can then be purchased for special applications, such as macrophotography, extreme telephotos, etc.

Keep in mind that despite focusing aids in the center of the reflex finder, the important thing is focusing on the ground glass itself. There are times, for example, when you might want to focus in the corner of the viewfinder, or on the bottom or top. That's the advantage of the reflex camera. If you are totally dependent on the central focusing aids, you might as well be working with a Leica M5, where the superprecise, central rangefinder area is much more accurate than any reflex focusing aid. Focusing aids are just what the name implies; they are *aids,* nothing more. The ground glass in your reflex camera is a total focusing area; it shows you what's in focus and what's out of focus, much as the film will see it—marvelous!

Infinity (∞)
Infinity is expressed thus: . Infinity relates to a point of focus with any lens beyond which everything will be in focus: with a 50mm lens, opened to $f/2$, for example, everything beyond 190 feet will be sharp when the lens is focused at ∞ .

The point in feet or meters at which infinity comes into effect varies with different focal length lenses at different apertures. Refer to depth of field tables in this book for the proper data.

Action Focusing

There are situations where it is sometimes difficult to focus because the subject is in motion. Of course, if the movement is at right angles to the camera, then the relative focus shift is slight. However, if the subject is in motion on or slightly off the camera axis, things can get a bit more difficult. There are two ways to handle such a situation. One way is to *follow focus,* stay with the subject as the distance between you and it narrows (or increases, if it's a receding subject). This takes a great degree of skill; cinematographers work in this manner and quite often it is an assistant rather than the cameraman who does the follow focus. Actually, the cinematographer has a somewhat easier job of it because his camera is running continuously. The still photographer, if he intends to pump off more than one shot, finds that the action, being interrupted by his trigger finger, keeps getting ahead of him. In regard to this problem, a motorized camera is helpful, for then, like the motion-picture cameraman, the still photographer can just hold the button down and concern himself with follow focus.

Another, easier method, is to *lead focus*—focus ahead of the subject, stay with it, and release the shutter when the subject moves into the plane of focus. This can be repeated as many times as necessary. Don't make the error of *panning* ahead of the subject, however. Keep it in the frame, designing the photograph as you go along and leading only with the focusing ring. You are focusing on a point *where it is going to be,* rather than on *where it is* at any given instant, and the idea is for you and the subject to arrive there simultaneously.

A variation on the above is the *prefocus* technique. The best example of this would involve a pole-vaulter—focus on the crossbar, follow him up, and release the shutter when he crosses the bar. In the case of an outfielder catching a fly ball, don't attempt to keep the ball in focus as it flies through the air, but rather prefocus on the outfielder and wait.

When shooting close up, in a tight situation, let's say a portrait, set your focus as accurately as possible, and as you make

the slight framing adjustments that are usually required, accomplish your *fine focusing* by shifting the upper part of your body backward or forward, instead of twisting constantly on the focusing ring. This is far simpler to do than it sounds, as all it involves is a slight bobbing back and forth, a natural action, and far less complicated than using the focusing ring. Try it.

Chapter Nine

DEPTH OF FIELD

Depth of field (often incorrectly called depth of focus*) is that area both in front of and beyond the point of focus which will still appear adequately sharp. In other words, there will always be an area of acceptable sharpness approximately one-third forward of and two-thirds behind the sharply focused subject. For example, a depth of field of 9 feet sets up an area of *adequate* field of focus extending from roughly 3 feet in front of the subject to 6 feet beyond the subject. If the subject moves anywhere within that area, it will remain relatively sharp.

It must be understood, however, that like the human eye, the camera lens has only *one point* of focus.† This point is infinitesimal and exists on only one thin plane at right angles to the axis of the lens. The term "depth of field" relates only to an area of *relatively* sharp focus.

Depth of field, then, is predicated on the final size of the viewed image. Most of the depth-of-field scales issued by lens manufacturers and engraved on lens barrels are predicated on "average" viewed image sizes. In other words, if your final product is an 8″ x 10″ print, or a slide projected on an "average-sized" screen to be viewed from an "average" distance, then the

* Depth of focus is an internal measurement that does not concern us at this point.

† Sharpness at this point is governed by the resolving power of the lens being used, resolving power of the film, etc., etc. Actually, there are no "absolutes."

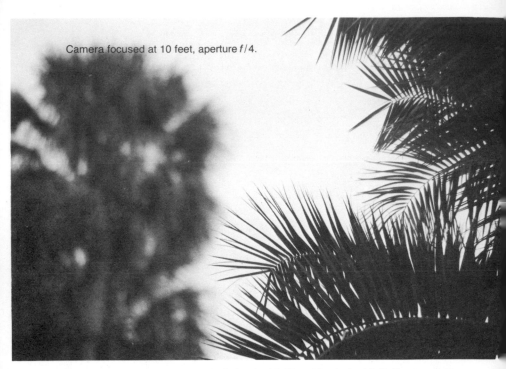

Camera focused at 10 feet, aperture f/4.

These two examples illustrate both depth of field and the lack of it. Both were shot with an 85mm lens. The distance to the near tree was, in both cases, 10½ feet. The far tree was at a distance of 28 feet.

Camera focused at 15 feet, aperture f/22.

depth of field you planned on will be adequate. The image will be reasonably sharp, both in front of and beyond the subject's point of focus. *But,* if your prints exceed 11" x 14", or if you intend projecting your slides on theater-sized screens, the depth of field you counted on will simply not be there. *Depth of field is relative. Depth of field deals with apparent sharpness—the greater the final magnification, the less apparent the sharpness!*

Depth of field is determined by the following factors:

1. *Aperture:* The smaller the lens aperture, the greater the depth of field. An aperture of $f/8$ will produce a greater depth of field than will an aperture of $f/2.8$.

2. *Focusing distance:* With any given lens, the greater the distance from lens to subject, the smaller the image size, and therefore the greater the depth of field. A given lens focused at 25 feet will produce more depth of field than the same lens focused at 15 feet.

3. *Final magnification:* The larger the final viewed image the less apparent the depth of field. A 16 " x 20" print, viewed from the same distance as an 8" x 10" print (made from the same negative), will appear to have less depth of field. In order for the two to appear equal, the 16" x 20" print would have to be viewed from four times the distance as would the 8" x 10" print.

Therefore, there are three ways to *control your depth of field:* (1) choice of f/stop; (2) image size, or distance from the subject with a given lens; (3) final print or projection size (relative to viewing distance). As a photographer, I refuse to be coerced into limiting the size of my prints or projections just to satisfy a natural law. If the subject calls for a 20" x 24" print, then that's what it gets . . . depth-of-field scales be damned!

That leaves two alternatives. Of the two, the choice of aperture is the more convenient tool. Being able to control depth of field through choice of f/stop is invaluable. Of course there are many occasions when this is not practical, such as when conditions call for maximum apertures due to dim light or the overriding need

for high, action-stopping shutter speeds. Aside from that, however, choosing your aperture in those situations where you are permitted a choice should be based as much on depth-of-field considerations as it is on any other factors. In fact, there are times, even when the light is adequate for handheld exposures, when you might decide to use a tripod, just to enable yourself to stop down to $f/16$ (or farther) in order to get the maximum depth possible. (Assuming that $f/16$ would require a shuttter speed too slow to handhold.) Then, of course, there are those situations when you might decide on a *minimum depth of field*. You accomplish this by using a larger $f/$stop.

The second of the two alternatives, subject distance, is actually relative to image size. (More on this a little later.) However, for the time being, let us say that the closer the subject, the shallower the field depth. This is a tool of sorts, but there are many times when camera-to-subject distance is determined by other, overriding considerations, both practical and aesthetic.

Before we go any further with the technicalities, it is important for the reader to understand the value of controlling or using depth of field. We'll start with selective focus.

Selective Focus

Selective focus is used primarily to isolate the subject by throwing the foreground and/or background out of focus. More often one chooses to put the background out of focus, as out of focus foregrounds, as a general rule, tend to be unpleasant to the eye —distracting. (General rules, of course, exist to be broken.)

In many cases, a confused background that is sharp is much more disconcerting than the same background thrown out of focus. Background elements, when sharply focused, might tend to draw the eye and attention away from the matter at hand. There is, in addition, a pleasant aesthetic quality to some types of unsharp background. The lines soften, and masses resolve themselves into soft shapes. The colors seem to lose some of

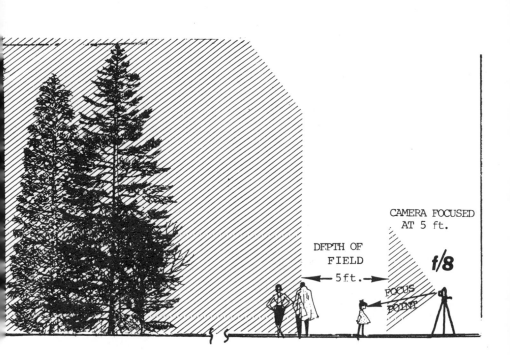

CAMERA FOCUSED
AT 5 ft.

DEPTH OF
FIELD

← 5ft. →

f/8

FOCUS
POINT

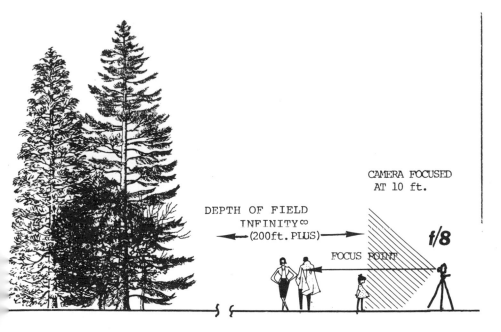

CAMERA FOCUSED
AT 10 ft.

DEPTH OF FIELD
INFINITY∞
← (200ft. PLUS) →

FOCUS POINT

f/8

DEPTH OF FIELD RELATIVE TO FOCUSING DISTANCE.
At any given *f*-stop, the depth of field will vary in direct proportion to the focusing
distance. Diagram indicates a 28mm lens. RULE: *The greater the focusing
distance, the greater the depth of field.* (Shaded areas indicate portions of the
foreground and background that would be unsharp in the resultant photographs.)

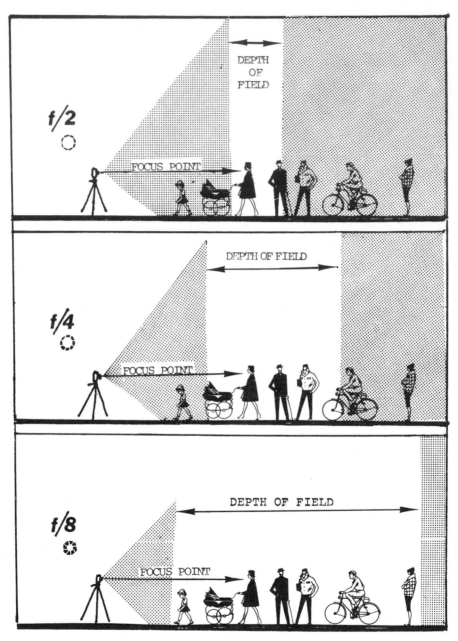

DEPTH OF FIELD RELATIVE TO LENS APERTURE.
At any given distance, the depth of field will vary in direct proportion to the f-stop.
RULE: *The smaller the lens aperture the greater the depth of field.* (Shaded areas indicate portions of the background and foreground that would be unsharp in the resultant photographs.)

their saturation and take on a sort of pastel quality. This is especially true if the background is somewhat overexposed, as it quite often is under these circumstances. In many situations it is enough just to indicate the background or the background action rather than show it in all its unnecessary sharp detail. By isolating the main subject through the use of selective focus, you reinforce its importance. The eye of the beholder will be drawn and held to the subject and will have less of a tendency to stray to that which is inconsequential. *A softly focused background can serve as a sketch of the environment within which the subject retains prime importance.*

Front Focusing

There are times when you might find it difficult (because of image size, distance from subject, bright light, etc.) to throw the background out of focus. In those situations, *front focusing* is called for. By focusing in *front* of the subject, at some point between it and the camera, you can control the focal depth so that it is just adequate to bring the main subject into sharp focus. Since the subject will then be on the far border of your depth of field, the background will be out of focus.

Deep Focus

Photographs that retain a needle-sharp focus from extreme foreground to extreme background, if accomplished successfully, can on rare occasions be a feast for and a surprise to the eye. *The eye focuses on only one point at a time.* It scans, it roves over its target, gathering data for the brain as it moves from one focal point to the next. The deep-focus photograph compresses the details of nature into a small oblong where everything is sharply defined, and the eye is required to scan to a far less degree, as it perceives much larger quanta of data from every focal point on the photograph. Such photographs can amplify the essence of

nature or the works of man, evoking an emotional response different from •and usually even more intense than that produced the original scene.

Deep focus requires, in order to establish the necessary depth of field, the smallest possible apertures. Unfortunately, many otherwise fine 35mm camera lenses have a tendency to lose resolving power at the small f/stops. I say many, but not all. The problem seems more acute with lenses in the normal focal lengths. I suggest that the reader test his lenses at various apertures on a standard target (newspaper, lens test chart, etc.) in order to ascertain whether they retain sharpness at small apertures.

Depth of field is achieved in part through the creative use of aperture control, and therefore f/stop decision is critical. One method through which you can arrive at this decision is to view through the finder with the lens actually stopped down. The control for this is a "preview button" or lever, found on the camera body or in some cases the lens itself. The preview control bypasses the automatic diaphragm mechanism and permits you to see the world much as the film will see it.

Ordinarily, if you were to set the diaphragm ring to, let us say, f/8, it would remain at its maximum opening until just before the shutter went off, at which time it would stop down to the preselected aperture (of f/8), then return to the fully opened aperture once the shutter had completed its cycle. However, if the preview control were activated, the lens would stop down to f/8 immediately and you could observe the scene through the lens aperture actually in use. This, of course, would enable you, the photographer, *to see your depth of field in the finder.* (This method is impossible with a rangefinder camera, as the viewfinder is separate and does not utilize the camera lens.)

The preview button or lever is the most *convenient* method of establishing aperture (f/stop) choice relative to depth of field. However, despite the fact that it actualy enables you to observe the depth of field, it is by no means the most *accurate* method. In

critical situations, a depth of field as observed in the finder should be thought of as an approximation. The reason for this is the apparent size of the viewfinder image—despite its magnification it is still small, too small actually for really precise evaluation of anything other than the actual point of focus.*But it is, however, a sufficiently accurate means of observing depth of field for purposes of selective focus. The prime consideration in this case is not an evaluation of *sharpness* (as with deep focus), but rather an evaluation of *unsharpness,* which requires much less in the way of an acute examination of the tiny ground glass on the part of the photographer. Remember, selective focus deals with out-of-focus backgrounds (or foregrounds), or *shallow depth of field.* Things get somewhat more critical when one attempts to establish a deeper field of focus.

When attempting to ascertain depth of field through the finder, the best insurance is to stop down one extra stop beyond what you believe to be adequate.

Depth-of-Field Scales

A depth-of-field scale consists of a chart that lists, either metrically or in feet and inches, the areas of sharpness both forward of and behind the focal point of a specific lens. Various distances are listed relative to a complete series of *f*/stops. The simplest type of depth-of-field scale is actually engraved on most lenses. However, even these are not completely dependable. In fact, because of the lack of an adequate number of footage indicators, they are somewhat impractical.

In Appendix Five the reader will find a large group of accurate depth-of-field scales. They are rather complex, so I suggest the reader use them as a guide in preparing his own charts for lenses in his possession. To simplify matters, it is further suggested that

* High magnification eyepieces are available for some cameras. They range in power up to 3X and slide or fold conveniently out of the way so that the full frame may be viewed.

the foot-plus-inches data be rounded off to the nearest 1½ foot. For near focus, round off by adding. For the far focus, round off by subtracting. (At distances beyond 10 feet, distances can be rounded off to a full foot).

Image Size and Depth of Field

For any given focal length (lens) the two variables determining depth of field are aperture and subject distance.

We have discussed aperture, let's now deal with subject distance. It must be added that the state above specifies a given focal length. In simpler terms, a given lens focused at 10 feet will have a greater depth of field than when focused at 5 feet. You can see by this that focusing on far objects results in more depth of field than does focusing on near objects. The greater the distance, the greater the amount of depth of field. An example: a 50mm lens focused at 5 feet (at f/11) will have a depth of field extending from roughly 1 foot in front of the subject to 3 feet behind the subject, a total depth of field of 3 feet. The same lens set at the same f/stop and focused at 10 feet will result in a depth of field extending from approximately 6½ feet forward of the subject to 13½ feet behind the subject, a depth of field totaling 20 feet, certainly a significant increase!

Put another way, as we move the camera farther from the subject, we reduce the size of the image on the film. As an example, let us visualize an oblong object having the same aspect ratio as the film frame of a 35mm camera to a rectangle measuring 360mm x 240mm. (We will deal here with the metric scale as it is easier to see the ratios.) You will notice that the size of the above rectangle is exactly 10X the size of the 35mm frame (36mm x 24mm). If, using any focal-length lens, we completely fill our viewfinder with this rectangular subject, the reduction ratio will be exactly 10 to 1. The term "reduction ratio" refers to relative image size. In this case the relative image size is 10 to 1, because the size of the subject is exactly 10X the size of the

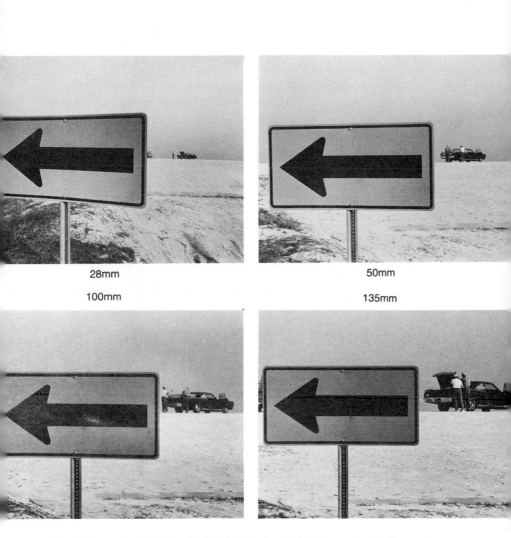

28mm

50mm

100mm

135mm

Four photographs illustrating the fact that depth of field is determined by image size and lens aperture. All four were shot at $f/16$. As the lenses were changed the photographer positioned himself in order to keep the foreground image (sign with arrow) the same size in each photograph. Note that depth of field is almost identical in all four photographs.

image on the film. (From this point on, we will drop the word "relative" and speak only of "image size.")

Therefore, any focal length lens, at a given f/*stop and a given image size, will, for all practical purposes, produce the same depth of field.** For example, a 100mm lens at 10 feet will project the same image size onto the film that a 50mm lens will project onto the film at 5 feet from the subject. In both cases the depth of field will be the same. The same would be true of a wide-angle, 25mm lens focused at 5 feet and a 50mm lens focused at 10 feet and a 100mm lens focused at 20 feet (assuming a common f/stop). *Image size* + f/*stop determines depth of field, regardless of the lens in use.*

Those readers who accept the fact that wide-angle lenses provide a greater depth of field (at short distances) than longer lenses are laboring under a very common misapprehension. Wide-angle lenses *seem* to provide more depth of field, simply because they produce smaller image sizes. *A wide-angle lens will produce a photograph in which the size of things is relatively small and thus will provide the photographer with an extended depth of field. However, at the same* f/*stop, the use of a 200mm telephoto lens would result in the same depth of field, if the photographer could get back far enough to produce the identical image size on the film as does the wide-angle lens.*

Conversely, if you made a closeup portrait, with the head filling the entire frame using a 180mm telephoto at f/2.8, and focused on the tip of the subject's nose, the depth of focus thus achieved would not include the subject's eyes. Nor would the subject's eyes be in focus if you substituted a 35mm or 28mm, or even a 17mm lens at f/2.8 and photographed the same image size. (Subject's head filling the frame.) Once again the depth of field would be the same because the image size and f/stop are the same.

* There are some specialized lens formulas that deviate slightly from this general rule.

Therefore, the myth concerning spectacular depth of field for wide-angle lenses is just that, a myth. It is not focal length that determines depth of field, but rather image size.

Photographers who believe in the "magical properties" of wide-angle lenses are in for occasional disappointments relative to depth of field, unless they stay reasonably long distances from their subjects. For example, an extreme wide-angle 24mm lens focused at 6 feet with an aperture of $f/11$ will be "sharp" from 6 feet to 26 feet. However, when focused at 1 foot ($f/11$), the depth will extend from 11 inches to 1 foot, a total of 1 inch, as compared to a depth of 20 feet for the first example.

To sum up, the intelligent use of depth of field is a valuable tool in terms of creative control. Learn to understand it and control it, to extend focal depth or minimize it to whatever degree you feel necessary.

Chapter Ten

EXPOSURE

The retina of the human eye, much like the film in a camera, has a specific *sensitivity* to light. So as not to overpower that sensitivity and damage (or overexpose) the sensitive retina, the eye possesses an iris that opens or closes according to the amount of light present in the field of vision. Thus, the retina receives image-bearing light that hopefully never exceeds a specific intensity level. Sometimes, in extremely bright sunlight, we help the iris at its job by further restricting the passage of light to the retina through the use of sunglasses, or, as they are known in certain quarters, "shades." I mention this in order to reinforce the analogy between the human eye and the camera. The camera, too, has an iris. Photographic film, much like the retina of the eye, also has a limited sensitivity to light. In some cases, under intense lighting conditions, it is even desirable for the camera to wear "shades" in the form of neutral-density filters (see Chapter Seventeen).

The name of the game is *exposure*. The amount of image-bearing light to which the film is exposed determines the exposure. In the human eye, the amount of image-bearing light that strikes the retina is controlled solely by the iris diaphragm. In the still camera the exposure is controlled by *the iris diaphragm in combination with the shutter*. The iris diaphragm controls the amount of light, the shutter its duration.

Diaphragm opening
(*f*/stops) = Exposure
Shutter Speed

The two are locked together. If you increase the diaphragm opening 100% by opening up one stop, you must, if you want to retain the same exposure, halve the shutter speed, Thus, for example, in terms of exposure *f*/8 at 1/60 sec. is essentially the same as *f*/5.6 at 1/125 sec., or *f*/4 at 1/250 sec., or *f*/2.8 at 1/500 sec., etc. *A one-stop aperture increase for a one-stop shutter decrease* if you desire to retain the same exposure.

Therefore, at any given exposure there is a wide choice of *f*/stop–shutter-speed combinations. The combination you choose at any given time is of great importance. High shutter speeds give you greater action-freezing potential—small apertures result in greater depth of field. (More on this subsequently.)

The shutter and the diaphragm *control* exposure, other factors *determine* it. These are film sensitivity, as expressed in ASA or E.I. ratings (see Chapter Six), and the amount of light falling on, or being reflected from, the subject,

Underexposure

Underexposure occurs when the image-bearing light passing through the lens onto the film is of an insufficient amount to reproduce the subject adequately. It occurs when

1. An ASA rating higher than that called for by the film is set into the meter.
2. There is inadequate light.
3. Shutter speed is too high.
4. Aperture is too small.
5. No exposure compensation has been allowed for a filter being used at the time.
6. The subject is a dark figure against a bright background

| ASA 125 | SHUTTER SPEED. . . . | 1/15 AT f/22 | 1/30 AT f/16 | 1/60 AT f/11 | 1/125 AT f/8 |
| | F-STOP | | | | |

| ASA 64 | F-STOP | f/22 AT 1/8 | f/16 AT 1/15 | f/11 AT 1/30 | f/8 AT 1/60 |
| | SHUTTER SPEED. . . . | | | | |

| ASA 32 | SHUTTER SPEED. . . . | 1/8 AT f/16 | 1/15 AT f/11 | 1/30 AT f/8 | 1/60 AT f/5.6 |
| | F-STOP | | | | |

The chart above lists equivalent exposures for 3 sample film types of differing ASA-ratings. In each column are eight separate exposure combinations, all equal in terms of the amount of light they project back to the film. In the three columns, there are a total of 24 shutter speed, F-stop combinations, all of which will produce exactly the same exposure and negative density on black and white film, or in the case of color film, exactly the same exposure.

and no compensation has been made relative to the reading from a reflected (or BTL) exposure meter.

7. The area being metered is too light in tone. (A reflected light reading of a "pure" white subject will result in approximately three stops under exposure.)

Overexposure

Overexposure occurs when the image-bearing light passing through the lens and onto the film is more than is needed to reproduce the subject. It occurs when

(Theoretical light source = 800 ft. candles)

1/250 AT f/5.6	1/500 AT f/4	1/1000 AT f/2.8	1/2000 AT f/2	E.V. 13
f/5.6 AT 1/125	f/4 AT 1/250	f/2.8 AT 1/500	f/2 AT 1/1000	E.V. 12
1/125 AT f/4	1/250 AT f/2.8	1/500 AT f/2	1/1000 AT f/1.4	E.V. 11

The Exposure-Value (E.V.) found at the end of each column is a rating representing corresponding shutter speed, f-stop combinations. E.V. scales are included on many hand-held exposure meters and begin at E.V. 0.50 extending to E.V. 20.. (some meters have even more extended scales).

1. An ASA rating lower than that called for by the film is set into the meter.
2. Shutter speed is too slow.
3. Aperture is too large.
4. The subject is brightly lit against a dark background and no compensation has been made relative to the reading from a reflected (or BTL) exposure meter.
5. The subject is too dark in tone (reflected reading).

There are a few other causes for over/underexposure, but they relate to the use of flash and will be dealt with later.

Chapter Eleven

EXPOSURE CONTROL

The Use of the Built-In (BTL) Camera Meter

As explained earlier, reflected-light meters are based on the presumption that the scene they are "reading" is reflecting 18% of the light that is falling on it. Therefore, the ideal means by which to make use of these meters would be to take readings of such objects that are guaranteed to reflect no more or no less than 18%. This is possible—available for a few bucks at your local camera store is an 18% reflectance "gray card." If you place this at the subject position and read it close up, on the axis of the subject and eventual camera position, a proper exposure will result.

Of course, it is obvious that the use of a gray card would probably be unwieldy outside the studio. This leaves a number of alternatives:

1. If you consider the scene, as perceived through the finder of your camera (in the case of a BTL meter), *average,* then you can go ahead and take your meter's word for things. An "average" scene is one in which there are not too many deep blacks or glaring whites, a scene that to the eye seems to run the gamut of tones. Front-lit scenics, evenly lit interiors, portraits, etc. fill the bill nicely and respond well to average-reflected-light metering.

2. If your built-in meter is of the spot or semispot variety, find a middle tone—a color or tone that lies roughly halfway

114

between pure white and pure black—and center the meter spot there for your reading.

3. Where the scene is contrasty, such as situations where spotlights are used, or where there is an overabundance of dark or light areas, the BTL meter has a problem. If it is a spot or semispot, and if the procedure mentioned in number 2 above is applicable, your troubles are over. (This might, of course, require you to get somewhat closer to the subject in order to fill the spot area.) In such situations with so-called averaging, or with center-weighted meters, you should attempt to get close enough to the subject to a point at which it fills half the frame. Or, you can mount a longer telephoto lens on your camera in order to increase the image size. (After arriving at an exposure, it can be replaced with another lens.) Then it becomes a simple matter to shift the camera slightly so that the subject image lies in that part of the finder that relates to the meter's area of maximum sensitivity. (The means by which you can ascertain this sensitive area was explained in Chapter Seven.)

4. If there is a situation as mentioned in number 3 above, and you cannot get close enough to the subject for a closeup or spot reading, then you can compensate as follows: For subjects that fill less than half the frame or spot area, but more than one-third, compensate one stop thus—if the surrounding area is dark, stop down one stop below the meter reading. If the surrounding area is bright, increase your exposure one stop. If the subject image fills between one-third and one-quarter of the frame or spot area, the compensation will be roughly one and a half to two stops. (Here too you must keep the subject within the area of maximum sensitivity.) In both cases it pays to *bracket* a half stop. "Bracketing" will be explained subsequently in this chapter.

5. If the situation as outlined in number 4 above is not applicable and the subject fills less than one-third of the frame or spot

* To learn to recognize this middle tone, it is worthwhile to have in your possession an 18% gray card to refer to, at least until you are able to recognize the tone in real life.

area, there are still a few alternatives left. If the area surrounding the subject in the finder is bright, stop down two stops and bracket two extra exposures, adding one stop and subtracting one stop from the compensated reading. If the surrounding area is dark, increase your exposure two stops and bracket one stop each way as above. Another expediency is to place your hand a foot or so in front of the lens, in the same amount of light that is falling on the subject, and obtain a reading from your flesh tone. (More on flesh tones a little later.)

6. When all else fails, you might have to dispense with the use of the meter and rely on experience. To aid in this department, there is a chart at the end of this chapter that reflects the author's experience—it should do until you accumulate enough of your own.

When reading subjects in or out of "average" surroundings, but which are themselves contrasty—consisting of heavy shadows and bright highlights—the range of tones may be outside the film's capability to register them. Such subjects may include, for example, a sunlit face, half in shadow, or the corner of a barn, one side of which is facing the sun, the other shaded. If, for example, the sunlit or highlighted side of either example were more than 16X brighter (in terms of footcandles) than the shadow side, the scene would be beyond the capability of color film in terms of recording highlight and shadow detail. With careful processing, it is possible to record such scenes on black and white film, but for the time being let us concentrate on color transparency problems as they are more critical.

What we are speaking of is the brightness range of the subject. Color transparency film, on the average, will record a brightness range of 16 to 1—the highlights 16X brighter than the shadows. Put simply, 16X = 4 stops of exposure. In technical terms, this means that if you took a reading of the shadow side of the barn (or face) resulting in an exposure of 1/60 sec., at $f/4$, and then you took a reading, using the same ASA rating and shutter speed of the bright side resulting in an exposure of $f/16$, the

brightness ratio would be four stops, or 16 to 1. Color film would not tolerate this range, if exposed at the midpoint of the brightness range. The midpoint in this example would be $f/8$, halfway between $f/16$ and $f/4$, or halfway between the brightness reading and the shadow reading. At this exposure the highlight side would produce, on the transparency, almost clear area, and the shadow side would result in blocked-up featureless shadows. The resultant slides would have overexposed highlights (plus two stops) and underexposed shadows (minus two stops). Black and white film, because of its greater range—tolerance to over- or under-exposure—could cope, but transparencies shot in this manner would be total disasters.

If, from the camera position, you were able to take a single reflected-light reading of either the barn or the portrait, and the scene were evenly divided between highlight and shadow, so that the meter reading consisted of 50% of each, then the resultant exposure would be at the midpoint ($f/8$ at 1/60) just as explained above, and just as unsatisfactory for color transparency film.

How to cope with excess contrast? Let's start with some general rules and go on from there.

General rule number one (color transparency): Expose for highlights. If you expose for shadows, your highlights might wash out, and nothing is worse for color transparencies than over-exposed highlights. You can live with blocked-up shadows— shadows into which the eye is unable to see, to make out details. This is natural to the eye; we are used to the idea of not being able to see into dark areas. But it is *unnatural* to the eye to have bright areas wash out completely into blank white. (Of course, all rules can be broken, and even washed-out, glaringly white, undelineated featureless highlights can occasionally serve a dramatic purpose—but let's stick with the rules, at least for now.) *Repeat*—when using color transparency film in contrasty-lighting situations, *expose for the highlights.*

General rule number two (black and white and color nega-

118 *35mm Photography*

tive): Expose for the midpoint in the brightness range. Under most contrasty situations, this expediency should produce a healthy and useful negative.

Unlike color transparencies, where highlights are composed of relatively clear or at least partially transparent film, on black and white negatives it is the highlights that have density and the shadow areas that tend to be clear film. Therefore, the greatest danger lies in underexposure, rather than overexposure as with color film. Underexposure will tend to leave shadows featureless, with no perceivable details in the clear areas of the film. Therefore, by exposing for the midpoint of a contrasty brightness range, there is far less possibility of losing shadow detail than if a highlight exposure is used. Care must be taken in such situations not to overdevelop the film, as this will result in highlights, which on the negative are blocked up and in some cases may be too dense to print.

General rule number three (black and white): Expose for the shadows, develop for the highlights. Put simply, this means overexpose and underdevelop—a cure for overly contrasty negatives that is almost as old as photography itself. This rule is an alternative and improvement on rule number 2. There are two ways in which it can be accomplished, both of which involve cutting back on development time.*

1. Set the meter to a lower ASA (E.I.) rating than that called for by the film. One stop, or 50%, is adequate. Thus, an ASA of 125 becomes an E.I. of 64. This will overexpose your film one stop, providing you are reading the midpoint on the brightness scale. Film development time should then be cut back.

* This book, because of the space limitations, will not attempt to deal with film processing or printing techniques. As a general rule of thumb, however (to be used only as a jumping-off point for further experimentation), I advise a 25% cutback in development time related to a 50% cut in the exposure index of the film. Thus, Tri-X, which is rated at ASA-400, and processed, for example, for 10 minutes in 1 to 1 D-76 (at 68°F) to produce a normal negative, can also be processed for 7½ minutes, to produce a lower contrast negative when exposed at E.I. 200.

2. Instead of exposing for the midpoint of the brightness scale, rate your film at its proper ASA and expose for a point halfway between the midpoint and the shadow reading. A reduction in development time will also be necessary. This method is a kind of rudimentary zone-system approach. (The zone system is a means whereby the photographer can, through the means of previsualization, control the final quality of his image. The infinite variety of possible photographic tones are grouped into ten "zones." Zone 0 is black, Zone 9 is white. Zone 5 is a middle gray. The photographer using subjective judgment can, when he has mastered the system, place each tone exactly where he wants it by correlating exposure and development. The zone system has become almost a way of life with many photographers, and was developed by the American photographer, Ansel Adams. There are many good books on the subject, one of the best being Minor White's *Zone System Manual* (Dobbs Ferry, N.Y.: Morgan & Morgan, 1968).

At this point, I feel I must reiterate the fact that, in a large percentage of situations, the brightness range is usually no more than 4 to 1, or two stops, an "average" scene. This means that with a built-in or handheld meter, the exposure will be based on the midpoint, allowing roughly one stop on either side. This is a safe ratio; just meter the scene through the camera and shoot. Your highlights will retain texture, your shadows will be open and detailed, both with color and with black and white. It's when the ratio exceeds 8 to 1 that the trouble sets in.

The Use of the Incident-Light Meter

The incident-light meter is operated from the subject position and pointed toward the camera. If the same light that is falling on the camera position is falling on the subject, it can be read at that position by pointing it away (180°) from the subject. The incident-light meter can also be pointed from the subject directly

toward the light source in order to measure actual light intensity. The light falling on the Ping-Pong-ball light receptor (photosphere) should be the same light that is falling on the subject, whether the subject be 10 feet or 10 miles away.

Normal Use in Relatively Uncontrasty (Flat) Light
(Color and Black and White)

From the subject position, point the meter directly at the camera lens. If the subject is too far away, place the meter in the same light that the subject is receiving and point it away from the subject, along the camera-subject axis.

Contrasty Light (Color)

If the subject is partially in bright light and partially in shadow, first determine the brightness range by pointing the photosphere away from the light on the subject axis, until the white ball is entirely in shadow, as is that part of the subject. Note the reading, then turn the photosphere until it is pointing directly at the light source. Take a second reading. If the brightness range is less than 4 to 1, or two stops, your final reading should be taken with the photosphere pointing directly at the camera lens (or on its axis, if the subject is remote). If the ratio is more than 4 to 1, but less than 8 to 1 (three stops), point the meter on an angle (or axis) halfway between the main light source and the camera. This means that if the light source is the sun, you might have to point the meter upward to accomplish this. You will note when you do this that the shadow falling on the white photosphere is now only covering about one-quarter of its surface—three-quarters of your reading is based on highlight, one-quarter based on shadow. If the brightness range is more than 8 to 1, point the photosphere directly at the light source. Now the entire white Ping-Pong-ball receptor is receiving incident light—there are no shadows on its surface and your exposure is based purely on a highlight reading. All of this is calculated to prevent overexposure and washed out highlights, a major problem with transparency film and its narrow latitude. As was

mentioned earlier, with color it is far better to lose shadow detail in contrasty lighting situations than it is to end up with washed-out, featureless highlights.

After awhile it will no longer be necessary to take separate readings with the incident meter in order to determine the approximate brightness range of your subject, as you will, with experience, begin to judge it adequately by eye . . . practice makes perfect.

Contrasty Light (Black and White)

Determine brightness range as above. If the brightness range is less than 8 to 1 (three stops or one and a half stops on either side of the midpoint), point the photosphere directly toward the camera lens from the subject position (or on its axis if the subject is remote). If the brightness range exceeds 8 to 1 (four stops), and you want to hold shadow detail, point the meter away from the main light source till three-quarters of the photosphere is covered with shadow. (This would place the axis of the photosphere about 135° away from the light source.) When processing the film, underdevelop by roughly 25%.* Another method to cope with extreme contrast when using black and white film is to read the incident light with the photosphere pointed directly at the lens, and when the brightness ratio exceeds 8 to 1 (four stops), overexpose the film one stop and cut back development as explained earlier.

Bracketing

"Bracketing" is a means of acquiring exposure insurance whenever doubt exists as to the proper exposure. If the photographer is being subjected to what we would call "a slight gnawing doubt," then a half-stop bracket in the direction of his uncertainty will usually be sufficient. In other words, if he believes he

* An approximation. Experimentation based on film and developer combinations is suggested.

might be overexposing slightly, a second exposure a half stop less than the original will probably be adequate insurance. If there is grave doubt, the insurance might call for as many as four extra exposures, in half-stop increments, two plus and two minus on each side of the original exposure. That totals a two-stop bracket, one-stop underexposure and one-stop overexposure. If the photographer feels that (with the occasional exception of *very* special circumstances) he needs more than two stops insurance, then I suggest he find a new career . . . finger painting is nice.

Bracketing is a valid tool used by practically all professionals at one time or another. It is especially useful if there is the slightest doubt that an exposure meter is functioning properly. It can also be used as an aesthetic tool, usually with color film, to run the gamut of tonal possibilities in a given situation: *Perhaps the subject might appear more dramatic if it were silhouetted, or the wall texture dramatized with less exposure, or the subject's skin tones darker, the shadow areas deeper, etc.* Shoot the first one normally and bracket for effect. It's certainly not the most economical approach, in terms of film, but it can pay off in terms of variations and peace of mind, particularly when the photographer is faced with difficult light situations.

"Creative" Underexposure (Color Transparency)

I find that rating color transparency film roughly 50% (a half stop) higher than recommended by the manufacturer produces deeper, more saturated color and helps to ensure against image-destroying overexposure. For example, Kodachrome 25 rated at E.I. 32, Ektachrome-X (ASA-64) rated at E.I. 100, etc. Purposeful underexposure is not recommended for black and white film.

Flesh Tones

If you were to take a reflected-light reading of "average"

Caucasian skin, and another reflected reading of "average" Black skin, and then proceed to make the two exposures at the indicated values, the resultant photograph of the Caucasian individual would be roughly one stop underexposed and the Black individual, roughly one stop overexposed.

You must remember that the reflected-light meter is attempting to match to a 40% gray—it is assuming that the skin tone it is reading is reflecting 18% of the light that is falling on it. Average Caucasian skin is lighter than that; it reflects well over 22% of the light that strikes it, while average Black skin is darker than 40% and reflects less than 12% of the light falling on it. If either of your subjects are not average in terms of skin tone— if the Caucasian person is dark complexioned or fashionably suntanned, and if the Black individual is somewhat lighter than "average," then your reading will probably be close enough to produce a reasonably accurate reproduction.

On the other hand, if both are exposed according to the meter reading, the resultant photographs will, at least theoretically, display exactly the same skin tone density. (One could go on about the social connotations, but this is certainly not the place for that kind of thing.) Suffice it to say that, at least in color, most Caucasians like to appear somewhat darker complexioned than they actually are. Short of that, if you are reading average Caucasian skin and desire *accurate* exposure, either rate your film 50% (one stop) lower in terms of ASA, or overexpose one full stop. If you desire accurate exposure when reading average Black skin, rate your film 100% higher or stop down one full stop.

Using this knowledge as a basic jumping-off point, you can learn to use the palm of your hand as a kind of gray card for making reflected-light readings when you're unable to find a neutral tone in the scene. After a few tests, it is a simple matter to establish exactly what the relationship is between the palm of your hand and a gray card; start by making a direct comparison using your camera (or reflected) meter. Once you've zeroed in on the difference in terms of exposure increase or decrease, it

then becomes possible to hold your hand in front of the meter or lens to take a reading of the reflected light in the general scene. Once more, it must be reiterated that the same light falling on the scene must fall on your hand, and that your hand should not be shadowed by the camera itself.

SUGGESTED EXPOSURES

Situation or Subject	ASA	F-stop	shutter speed
Average room light at night. Shaded lamps	400	f/2	1/30
Some overhead light (non fluorescent)	400	f/2.8	1/30
(Type B color film, 1 stop push)	250	f/2–f/2.8	1/30
Circuses and similar arena shows.	400	f/3.5	1/125
Lit primarily with tungsten house-lights.	250*	f/2.8	1/125
(Floodlights)	125	f/2	1/125
*(Type B color film, 1 stop push)			
Circus acts and similar arena activities.			
Lit with carbon arc spotlights.	400	f/4	1/250
	320*	f/2.8–f/4	1/250
Daylight color film.	160	f/2.8–f/4	1/125
	100	f/2–f/2.8	1/125
*(High Speed Ekt., 1 stop push)	64	f/2.8	1/60
Rock concerts and similar attractions.	400	f/2.8	1/250
Lit with carbon arc spots.	320*	f/2.8–f/4	1/125
	160	f/2–f/2.8	1/125
Daylight color film.	100	f/2–f/2.8	1/60
*(High speed Ekt., 1 stop push)			
Hockey and basketball.	400	f/2	1/250
Tungsten light. (flood)	320*	f/2	1/120
*(Type B color film, 1-1/3rd stop push)			
Arena activity under mercury vapor light,	400(B&W)	f/2.8–f/4	1/250
using recommended CC30M filter with day-	320*	f/2.8–f/4	1/125
light color film. (not needed for B&W)	160 (CLR.)	f/2.8–f/4	1/60
Filter factor included.	100 (CLR.)	f/2.8	1/60

*(High speed Ekt., 1 stop push)
For mercury-vapor lit night football or baseball, open one stop

SUGGESTED EXPOSURES — cont'd.

Situation or Subject	ASA	F-stop	shutter speed
Night football, baseball, floodlit.	400	f/4	1/125
	250*	f/2.8-f/4	1/125
*(Type B color film, 1 stop push)	125	f/2-f/2.8	1/125
Interiors, lit with bright fluorescent lights,	400 (B&W)	f/2.8	1/125
using FLD filter with daylight color film.	320	f/2.8	1/60
(Filter not required for B&W) Filter factor	160 (CLR)	f/2	1/60
included.	125 (B&W)	f/2-f2.8	1/60
	100 (CLR)	f/2-f/2.8	1/30
Bright neon signs, etc.	400	f/4	1/60
	160	f/2.8	1/60
Daylight or type B film may be used with	125	f/2.8	1/30
neon. For tungsten lit signs use Type B.	64	f/2	1/30
Fires, considerable flame and smoke	400	f/2.8	1/60
(Will expose nearby firemen, equipment,	320*	f/2.8	1/60
etc.)			
*(Type B color film, 1-1/3 stop push)			
Downtown streets (Times Square, etc.) lit	400	f/2.8-f/4	1/60
with neon signs and general night lighting.	320*	f/2.8-f/4	1/60
	320**	f/2.8-f/4	1/60
Daylight color film tends to be cold, type-B			
film tends to be warm.			
*(Type B film, 1-1/3 stop push)			
**(High speed Ekt., 1 stop push)			
Moonlit scenes (full moon)	400	f/4	5 sec.
	160	f/2.8	15 sec.

Suggested exposures may vary due to differing conditions. A one stop bracket is recommended when in doubt.

Chapter Twelve

PERSPECTIVE

The 35mm camera, with its almost infinite choice of lenses, is by far the most creative instrument in photography. One good reason for this is its almost total ability to control perspective. No other format comes close. The photographer who makes full use of the range of lenses available for 35mm photography has at his command an almost magical creative tool.

Perspective is controlled entirely by lens choice. A long, or telephoto, lens will tend to flatten perspective, causing optical *shrinkage* of the distance between near and far objects.

Wide-angle lenses create perspective distortion, causing a visual, or optical *increase* in the distance between near and far.

A 21mm wide-angle lens will cover a subject area roughly 4X larger than a 100mm lens. Put another way, its field of view will be 4X wider. A 21mm lens, for example, encompasses a wide field of 91°, while a 100mm telephoto encompasses a narrower field of just 24°.

Consider two people separated by, let us say, 20 feet. Keeping the image size of the foreground subject the same, make a picture with a wide-angle lens and then with a telephoto. When you check the results, you will see that although *the foreground subject in each photograph is the same size, the background subject will vary considerably,* depending on the focal lengths of the two lenses. If you had used a 100mm telephoto and a 21mm wide

126

angle, the background subject in the wide-angle photograph would be roughly one-quarter the size of the same figure in the tele-photo photograph. Neither of the two would be considered "normal" perspective. Normal perspective is achieved with lenses of 50mm, give or take 10mm or so.

The ability to control size relationships is, in my opinion, the main function of interchangeable lenses. A nose too big? Flatten it with anything from an 85mm to a 135mm. A desire to exaggerate the height and looming quality of a large structure, a building, a tree, an authority figure? Shoot from the ground up with a 24mm or 28mm. Isolate a figure against the sky without the necessity of including background or horizon? Use a 135mm to 500mm. Expand visually the interior space of a room, a car, an aircraft cockpit? Use anything from a 16mm to a 35mm. An environmental portrait in which the total ambience is dominated by the subject? Try a 28mm.

Size relationships, the illusion of distance, the feeling of space, whether constricted and compressed (as with a telephoto) or widened and infinite (as with a wide angle), are part of the "grammar" of photography.

Every photographer has a point of view. Two major factors involved in presenting a point of view are angle of view and perspective. It stands to reason that if a photographer does not consider *his* point of view and act on it, he could easily be replaced by an unattended camera clamped to a post and sequenced to expose a frame every 10 sec. or so.

Angle of view and perspective go hand in hand. A wide-angle lens, for instance, might present the subject as dominating his surroundings, while the use of a telephoto might cause him to merge into his surroundings. One scene, two entirely different interpretations.

In one type of photography, photojournalism (documentary, reportage, call it what you will), the choice of lenses relative to their focal lengths assumes even another importance, that of orienting the viewer (of the final picture) in psychological terms.

28mm

50mm

90mm

135mm

200mm

Perspective differences brought about through the use of five different focal-length lenses. Compare the relative size of the posts with the large structure in the background and also note the perspective changes in the row of posts.

If, for example, the subject is an event involving people, then the use of wide-angle and normal lenses will require the photographer to move in close and become part of the actual happening. The resultant photographs will place the viewer in the center of the action—involved. The use of a telephoto lens focused on the same scene will project an entirely different point of view. In this case, regardless of the image size on the film, the photograph will project the idea of a distant viewpoint. Most people today are unconsciously aware of the fact that a flattened perspective in a film or photograph indicates that the camera was remote from the subject. Such photographs have a way of engendering a voyeuristic impression, as if the viewer, uninvolved and unobserved, were watching the event. Put simply, the wide-angle lens has a tendency to produce subjective images while the telephoto has a tendency to produce objective images. Either is valid and each, in its way, portrays "truth."

Wide-Angle Distortion

Wide-angle lenses distort perspective on all planes. Parallel lines converge much more radically than with other lenses. This means that if a camera mounting a wide-angle lens is pointed upward even slightly, all of the vertical lines in the photograph will tilt inward toward the top in order to meet at some imaginary point beyond the bounds of the photograph. Point the camera downward and these lines converge toward the bottom. The same holds true for horizontal lines; a camera mounting a wide-angle lens, when pointed off to the right, will cause all parallel horizontal lines to converge to the right. Of course, longer lenses do this also, but to a lesser degree. The longer the lens, the less the distortion.

Knowing this, the photographer, when photographing subjects such as room interiors or outdoor structures, etc., where there are repetitive vertical and horizontal lines, can to a large degree control the distortion. If he desires to keep his vertical lines paral-

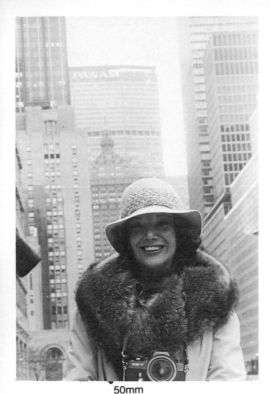

50mm

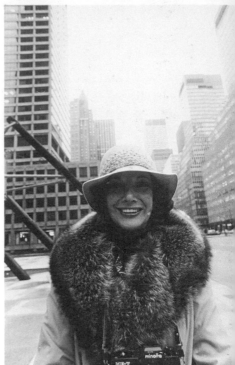

17mm

21mm

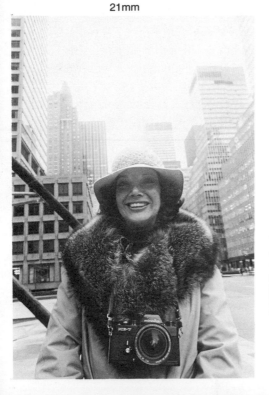

Three photographs illustrating the distortive qualities of extreme wide-angle lenses. Image size was kept constant by having the subject step back from the camera as focal length was increased. Compare the distortion inherent in both the 21mm and 17mm lenses with that of the normal 50mm lens.

lel, he should level his camera carefully, particularly with extreme wide-angle lenses. If it is really a problem, then he can back off and use a longer lens that has less inherent distortion. Another aid in this department would be the use of a lens such as the Nikkor 35mm PC, an optic that incorporates shifting movements of the lens, thus permitting the film plane and the subject to remain parallel.

It must be pointed out that wide-angle distortion is a fact of nature, not of lens design. The eye also sees converging lines when it looks up at, for example, a tall building. If the focal length of the eye were shorter, these lines would converge at a much steeper angle, and if the focal length were longer, they would converge at a much lesser angle.

There is another kind of distortion inherent in wide-angle lenses, barrel distortion, or the *curving* of straight lines, which becomes more acute toward the outer edges of the photograph. It is called barrel distortion because the curved lines bow outward much like the sides of a barrel. In moderate wide-angle lenses of quality, barrel distortion is very well corrected. However, in wide-angle lenses of focal lengths less than 24mm, it is a considerable design problem. Some extreme wide angles have managed to avoid barrel distortion almost completely. One amazing example is the 17mm Minolta Rokkor.

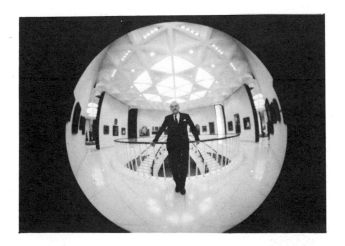

Fish eye Lens

The widest-angle lens currently available is the 6mm Fisheye-Nikkor, which covers an angle of 220°, and actually photographs an area behind the camera! Fisheyes covering 180° are available from many other camera manufacturers, and illustrate barrel distortion gone berserk . . . the resultant photographs are actually circular!

Part Three

LIGHT

A thorough understanding of light and color is a necessity for any photographer. Such knowledge can give him control over his medium almost equal to that of a painter. The photographer, like the painter, can, if he understands the tools available to him, control, distort, and manipulate color, either with great subtlety or with vivid blatancy. He can also, with black and white film, control the tone and density of blue skies, red roses, or complexions.

The purpose of the next few chapters is to explain as simply as possible the workings and functions of light in photography, and to present to the reader those tools necessary to control and modify light sources, whether they be nature's or man's.

Chapter Thirteen

LIGHT AND COLOR THEORY

Color Temperature

Visible light takes up just a minuscule portion of the total electromagnetic spectrum. We perceive this as white light, but in actuality it is a group of wavelengths ranging from 0.000016 to 0.000028 inch, from deep blue to bright red. This blending or mixture we relate to as "white light." The three important colors in the visible spectrum are blue, green, and red. Blue is the shortest wavelength and red the longest. When thought of in terms of temperature, blue light is higher numerically than red light.

Red is at one end of the visible spectrum, blue at the other. *"White light" is balanced either toward the blue or toward the red. A red shift is thought of as "warm" and a blue shift is thought of as "cold."* The means of measuring the amount of shift is called *Kelvin temperature,* and is measured in degrees of Kelvin. Sunlight is from 5500°K to 6000°K. Tungsten light, balanced for Type B film, is provided in the form of special photographic lights which are rated 3200°K, and for Type A film, 3400°K. An ordinary 100-watt household lamp burns at about 2900°K, and in terms of such household lamps, the higher the wattage, the higher the color temperature.

There are times when the blue-green-red combination might be somewhat out of balance. Tungsten light, for example, is of a low temperature and balanced toward the red; predawn day-

light is heavy on the blue end and lacks red; sunrises and sunsets are red and lack blue; fluorescent light is predominantly green, lacking red and blue. And yet, in most of these cases, the brain registers the light as "white."

Unlike the human brain, photographic film does not automatically compensate for changes in color balance or temperature. Daylight-type color film has a sensitivity balance equal to the combination of blue-green-red inherent in sunlight. If exposed under incandescent light, which is balanced toward the red end of the spectrum *and thus lacks blue,* the resultant photographs will appear reddish.

Tungsten film (Type A, Type B) has an emulsion with a heightened sensitivity to blue, a color that is somewhat lacking in the spectrum of incandescent lights. Therefore, tungsten film, when shot indoors under the proper conditions, will appear "normal." If tungsten-type film is exposed outdoors, in sunlight, the excessive blue sensitivity will result in a photograph sporting an overall blue shift.

To reiterate: High color temperatures tend toward the blue or cool end of the spectrum. Low color temperatures tend toward the red or warm end of the spectrum.*

Additive and Subtractive Color

In the earlier chapter on film we discussed the additive colors of blue, red, and green, and the subtractive colors of magenta, yellow, and cyan, in reference to their function in color film. It is now time to deal with them in terms of their interrelationships.

All light, regardless of its color, is made up of blue light, red light, and green light in varying proportions. These are the photographic primaries.† What happens when we mix or blend light sources of only two of these colors?

* The terms "warm" and "cool" refer only to a subjective reaction to red and blue and have nothing to do with heat or temperature.

† Not to be confused with the pigment primaries we learned about in grammar school (red-blue-yellow). We speak here of light, not pigments or dyes.

Red		
+	=	Magenta†
Blue		

Red		
+	=	Yellow
Green		

Blue		
+	=	Cyan‡
Green		

Magenta, yellow, and cyan are considered subtractive colors. "Subtractive" refers to their function. For example, if a cyan filter (transparent cyan-colored glass or plastic) is placed so that white light passes through it, the filter will *subtract* the red portion of the light. Therefore, if a light source is too red, you would use a cyan filter to subtract or absorb the unwanted red. The degree of subtraction or absorption would depend on the density or strength of the filter. Check the diagram above and you will see that *cyan* is made up of blue and green light. Of the three primaries, cyan contains only blue and green. Therefore, *cyan is minus red. Cyan absorbs red.*

Subtractive		*Additive*
Cyanis minus	
	will absorbRed
Yellowis minus	
	will absorbBlue
Magentais minus	
	will absorbGreen

A subtractive filter through which white light is passed will, in

† A kind of deep pink.
‡ A greenish-blue.

each of the above cases, subtract a corresponding portion from its additive complement.

Any two subtractive colors in the form of filters may be used together. For example, a combination of two filters, one yellow, the other magenta, will absorb green and blue. Think of it this way: magenta is minus green and yellow is minus blue. These two subtractive colors, blended into a filter, would appear to have a reddish or salmon hue.

Subtractive Filters	Appear to the Eye as	Absorbs
Magenta + Yellow	Salmon, orange, or red	Green and blue
Magenta + Cyan	Bluish	Green and red
Cyan + Yellow	Greenish	Red and blue

Of the three subtractives colors, no more than two can be used as filters at any given time. Adding the third would create a degree of *neutral density,* or gray. In many cases, as the chart above demonstrates, single filters made for color film actually combine two subtractive colors. For example, a filter made up of yellow and magenta would absorb blue and green, allowing red to pass unmolested. Such filters might be heavier on one color and lighter on another—thus, a combination of yellow and magenta with the yellow predominating would allow all the red to pass, while absorbing a small amount of green and a larger amount of blue. There are many such combinations.

One such combination is the 80A filter, used to convert day-light-type film for use under tungsten light. To the eye, this

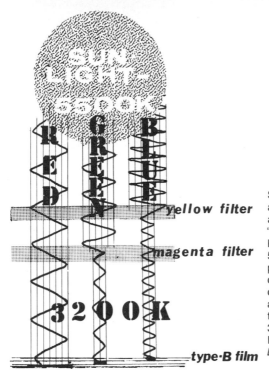

Sunlight consists of red, blue, and green light, which on an average sunny day results in "photographic daylight" and a Kelvin temperature reading of 5500°. When this light is passed through a filter, or a combination of filters consisting of proper amounts of magenta and yellow, the light is reduced to a Kelvin temperature of 3200°, for which type B Ektachrome is balanced. *Diagram by Jerry Yulsman*

filter is in the bluish family, made up of cyan and magenta, with the cyan predominating. Under normal circumstances, daylight film, when exposed under tungsten light, goes red, because of an excess of red and a lack of blue in tungsten light. (Type B and Type A film, as we know, are balanced for this discrepancy.) By placing the 80A over the lens, the tungsten light is compensated for use with daylight film in the following manner: The cyan portion of the filter absorbs a percentage of the excess red, the magenta portion subtracts a smaller percentage of the green. (Cyan is minus red—magenta is minus green.) The blue portion of the "white" tungsten light is allowed to pass undiminished through both subtractive colors that go to make up the filter, because as you can see in the earlier chart, both magenta and cyan have blue constituents. Therefore, by blocking the correct proportions of the other two primaries, the color balance is thus shifted back toward the blue end of the spectrum, for which daylight film is balanced. The diagram below illustrates this phenomenon.

The additive primaries react in quite a different manner when used as filters. A single additive filter will block or absorb both of the other two primaries. In other words, a red filter will permit only red to pass freely, while absorbing green and blue. If the additive filter is heavy enough* it will absorb all of the other colors.

It follows then that the additive colors can only be blended into subtractive colors through the use of transmitted light.† Their functions as filters is solely that of blocking or absorbing all other colors. Blue absorbs red and green, red absorbs blue and green, green absorbs red and blue. The degree to which this occurs is dependent upon the rated strength of the filters.

Additive filters are generally for use with black and white film (though they can be used with color for special effects). A red filter, for example, will absorb the blue of the sky and green of the grass, resulting in a black and white print displaying a deep sky and dark foliage. A green filter will absorb the blue of the sky and the red of flowers, resulting in a deep sky, dark-toned flowers, and very light foliage. A blue filter used in the same situation will absorb the green of the grass and the red of the flowers, resulting in dark foliage, dark flowers, and a white sky. Subtractive filters are also used with black and white film: A yellow filter used in the above situation will absorb some of the blue sky, resulting in a darkened sky and normally represented flowers and foliage. (Yellow, as you might recall, is minus blue, and will pass undisturbed the colors red and green.) The practical use of filters for black and white and color film is explained more fully in Chapter Seventeen.

* Such filters are called tricolor filters or process filters and are used to make color separations. They also have other applications.

† As an experiment, line up three projectors, each with a different additive filter of equal value over the lens. When all three are superimposed, the result will be white light. Any two of them will produce their subtractive complement. All three filters mounted on one projector lens will produce a gray image, or none at all, depending on filter strength.

Chapter Fourteen

SHOOTING IN DAYLIGHT

As mentioned in a previous chapter, all color films are balanced for either daylight or incandescent (tungsten) light. The redness of incandescent light or the blueness of daylight is measured in degrees of Kelvin temperature. The bluer the light the higher the rating. Thus, daylight film is manufactured and rated for light of about 6000°K, which is the color temperature encountered under sunny, blue-sky, midday conditions. Tungsten films are balanced for a temperature of 3200°K or 3400°K, which is the color temperature of incandescent light bulbs and lighting equipment especially made for color photography. Black and white films, for all practical purposes, remain unaffected by normal changes in color temperature.

Daylight color temperature varies somewhat according to the time of day, but generally stays within tolerable limits until about an hour and a half before sunset and an hour or so after dawn. Dawn and sunset light are noticeably red. The closer the sun to the horizon, the redder the light. Paradoxically, the light is bluish during the few minutes of daylight that exist after the sun has actually descended beyond the horizon at sunset, or before it has risen above the horizon at dawn. The eye can accept red sunset or blue predawn light on color film as indicative of the time of day, provided there are additional clues. For example, when shooting in the reddish light of a sunset, you can include the actual sunset along with your somewhat reddish-colored subjects.

141

On the other hand, the bluish light of predawn will often be accepted for what it is.

Skylight, as opposed to sunlight, is not nearly as red. Therefore, shooting *into* the sunset or the sunrise, with your subject backlit by red sky and frontlit by blue sky, can be quite dramatic.

Skylight, that portion of daylight that emanates from the open sky, is partially composed of ultraviolet (UV) light, which, though invisible to the human eye, is quite visible to photographic film. In fact, it is as much a part of the photographic spectrum as are red, blue, and green. Color film registers this invisible light as blue. Under conditions in which the sun's light is the main source of illumination (on near subjects), the UV emanations are minimal and may be disregarded. Under skylight, however, where the sun's rays are not falling directly on the subject, UV wavelengths tend to be more prominent (relative to the total spectrum). The problem is most critical in open shade—under trees, in shaded areas created by buildings, etc. A skylight filter is recommended to solve this problem.

Ultraviolet haze, which develops photographically in long shots, can also leave its stamp of unwanted blue cast on landscapes and aerial photographs.

There are two types of filter that are recommended to combat this problem. They are the haze filter and the UV filter. Chapter 17 deals in detail with their uses. Suffice it to say at this point that both types work well in combating the blues and piercing the haze.

Sunlight, because it emanates from such a powerful source, is naturally responsible for the extremely contrasty lighting conditions of sunlit daytime photography. An obvious statement, and yet, if you look at lunar surface photographs, it is immediately evident that sunlight on the moon is even more contrasty than on our home planet. The fact that the moon has no atmosphere explains that phenomenon. The earth's atmosphere scatters and diffuses sunlight into skylight. Skylight modifies the strong shadows created by the sun. This soft, diffused light from the open sky tends to "fill" shadow areas.

As explained earlier, the term "brightness range" defines a

film's ability to record the darkest and lightest tones in a scene. When the brightness range of a given film is inadequate, portions of the scene that are too bright will record as white, and portions that are too dark will record as black. These white and black areas will be featureless and devoid of detail. Actually what often happens when the brightness range of a given film is exceeded by the contrast of the subject is overexposure and underexposure simultaneously on the same film. Under ideal conditions, skylight fill is enough to bring sunlit subjects into a brightness range satisfactory for black and white film. On the other hand, the subject-brightness range of color film, though aided considerably by skylight fill, is sometimes not quite extended enough to deal with such high contrast.

Fortunately, all exposure meters have been calibrated with sunlit front lighting in mind. They will generally provide an exposure that will ensure highlight detail under average daytime circumstances. However, in these sunlit scenes, shadow detail will tend to be lost, particularly on color film.

There are ways to provide additional fill-in lighting in order to cut down the severe brightness range of sunlight. Daylight flash is one such method. (See the section on synchro sunlight in Chapter Eighteen. Reflectors are also available—or can be easily constructed out of aluminum foil—which serve the same purpose by reflecting light back onto the dark side of the subject. The nearer the subject, the greater the need for fill light. Long shots do not require fill-in light to anywhere near the same extent.

The worst time to shoot is midday, with the naked sun directly overhead. Ugly shadows are cast on faces, and sometimes even the most efficient use of portable fill lights or reflectors is not satisfactory.* The best way around this is to shoot your subjects in shaded areas or to stick to long shots where ugly shadows are not as obvious, or to go to lunch for a few hours. Scenes that do not involve people are of course exempt from this problem.

* However, in many instances, additional fill is provided by reflection from light-colored surroundings, including the ground itself. This is often sufficient to soften shadows considerably.

Flat light such as overcast or open shade when used in portraiture will not result in squinting and will insure against ugly shadows.

When shooting documentaries under these conditions, where you cannot postpone and have no control over the subjects, a high camera angle is recommended. As for the old cliché of placing the sun over your shoulder when shooting—be careful, especially with portraits. In this position, your subjects are facing directly into the sun and you're likely to be in for some squinting. The lower the sun, the greater the squint factor. If at all possible, try getting the sun angled somewhat off the camera axis. Around 20° to 30° is okay and makes for nice modeling without running into the squint area. The old sun-over-the-shoulder cliché is also baloney when applied to scenics and what-have-you. It is a flat light with very little character. Avoid it when possible.

Do, however, choose nice overcast days, particularly when shooting people. A light overcast is best. Shadows are just barely discernible, and the brightness range is rarely greater than one stop. The camera can be pointed in any direction without concern

and there is just enough subject modeling to keep things interesting. Colors in this type of light have a tendency to be more intense or saturated because of the lack of glare and surface reflection usually caused by naked sunlight.

Backlighting on sunny days is another good type of lighting. When backlit by the sun, the subject is actually being frontlit by skylight, plus sunlight reflected off nearby buildings, etc. The danger here is the tendency of the sun to shine directly into the lens. This can cause "flare," which sometimes registers as round or octagonal spectral patterns on the film. A lens shade or hood helps keep the sun out of the lens, but when the sun is low in the sky, an additional safeguard is required. A piece of dark cardboard about a foot square can be used to shade the lens. It requires a light stand, or an assistant to hold it, and should actually cast its shadow over the lens itself. Make sure it is not visible in the camera finder. The dramatic beauty of backlighting is worth the extra effort. When using backlighting, take a closeup reading, or better yet, use an incident-light meter.

Chapter Fifteen

SHOOTING IN INCANDESCENT LIGHT

There are three factors involving incandescent light that are of importance to the photographer:

1. *Intensity:* Naturally, the brighter the light, the better. Special light sources available for photography range in power from about 250 watts to 1000 watts. (There are higher wattages available, but not for general purposes.)

2. *Color temperature:* The color temperature of varying light sources differs greatly. However, *light sources especially made for color photography* are balanced for either 3200°K. (Type B film), 3400°K (Type A film), or 4800°–6000°K (daylight film).

The difficulty, of course, is that a variety of light sources are used for *nonphotographic* purposes, and the photographer is quite often stuck with them. The chapter on filters will be helpful in this regard. (Of course, as we know, color temperature, for the cost part, relates only to color film).

3. *Diameter of the light source:* When we speak of the actual physical size of the source of light, we are of course referring to it in relation to the subject. A 10-inch reflector mounting a 500-watt bulb at 3 feet from the subject becomes smaller (relatively) when moved back to 10 feet. The general rule is that the larger the light source, the *softer* the light. The term "soft" refers to the amount of fill-in in the shadow areas and the delineation of the

146

line that separates shadow from highlight. A shadow that is well delineated is usually the product of a *hard* light; a shadow that seems to segue out of the highlights is the result of a *soft* light. Soft light creates a feeling of roundness, usually referred to as "modeling." This is because the transition from highlight to shadow is gentle and progressive, indicating roundness and plasticity.

When a light, regardless of its initial physical size, is bounced off a ceiling or wall, so that the subject is lit by the resultant *bounce light,* the effect will be relatively soft, because the light *source* is actually the brightly lit wall itself—a large source indeed.

Therefore, the larger the diameter of light being bounced off the wall or ceiling, the softer the light. Diffusers, made of fiberglass or other materials (tracing paper, opal plastic*), when placed in front of the light source, also have a tendency to soften the light. Sheets of diffusing material are easily attached to reflectors through the use of clothespins.

Spotlights, when adjusted to their narrowest beam, give harder light than when operated in the spread position. To reiterate: *The smaller the light source, the harder the light.*

Types of Light Bulbs

There are two major types of incandescent light bulbs made for photography: tungsten and tungsten-halogen. Tungsten bulbs have household-type screw bases and come in various wattages with Kelvin temperatures of 3200°K, 3400°K, and 4800°K. They are inexpensive, but have relatively short life-spans. Reflectors of many types are made to accept tungsten bulbs, but for average use, 10-inch or 12-inch satin-finish reflectors are recommended. Also available are sealed-beam tungsten bulbs, which are excel-

* Both tracing paper and opal plastic are fire hazards. Fiberglass is safer and can be obtained from most large photographic shops. Under no circumstances should diffusing material come into contact with hot light bulbs.

SOME RECOMMENDED PHOTOGRAPHIC LIGHT SOURCES
(120 volts)

Manufacturer's Code and Type	Watts	Color Temp.	Average Life	Remarks
ECT Tungsten, household type screw base. Flood.	500	3200ºK* (type–B)	60 hrs.	General purpose for use with 10 inch and larger reflectors.
ECA Tungsten, household type screw base. Flood.	250	3200ºK* (type–B)	20 hrs.	Same as ECT but with approximately half the light output. May also be used in room fixtures, such as lamps, in order to bring up their level when photographing interiors.
EBV Tungsten, household type screw base. Flood.	500	3400ºK* (type–A)	6 hrs.	Same as ECT, but approximately 25% brighter.
BBA Tungsten, household type screw base. Flood.	500	3400ºK* (type–A)	3 hrs.	Same as ECA, but approximately 25% brighter.
EBW Tungsten, household type screw base. Blue flood.	500	4800ºK* (daylight)	6 hrs.	Light balanced for use with daylight film. Output roughly half of ECT. (Not recommended for use as a main light source—can be used with daylight or blue flash as fill, etc.)
RFL-2 Tungsten, sealed beam flood (built-in reflector). Household type screw base.	500	3400ºK* (type–A)	6 hrs.	Because this bulb has a built-in sealed reflector, all that is required is a light socket mounted on alligator clamp, or similar device. Excellent for bounce or umbrella light. Special barn doors to fit on bulb available. Beam angle— 90º.

SOME RECOMMENDED PHOTOGRAPHIC LIGHT SOURCES
(120 volts) — cont'd

Manufacturer's Code and Type	Watts	Color Temp.	Average Life	Remarks
EAL Tungsten, sealed beam flood (built-in reflector). Household type screw base.	500	3200°K* (type–B)	15 hrs.	Same as RFL-2 except for color-temperature and beam angle of 60°.
RSP-2 Tungsten, sealed beam spotlight (built-in reflector). Household type screw base.	500	3400°K*	6 hrs.	Built-in sealed reflector. Excellent for ceiling bounce. Special barn doors available to fit bulb. Beam angle—20°.
DVY, Tungsten-Halogen. Mounted in amateur-type (inexpensive) movielight with lightstand bracket.	650	3400°K (type–A)	25 hrs.	These bulbs are two-pin types, usually mounted in inexpensive movie-lights, manufactured to mount on the top of super-8mm movie cameras. Such lighting units can be purchased with a bracket to fit on a light stand. Movie-lights are excellent for bouncing into umbrella and for ceiling or wall bouncelight. For the amount of light they put out, they are extremely portable. They do not drop in color temperature as they age. Care must be taken not to jolt lights when they are hot, because of extremely fragile filaments. Movie-lights also display a tendency towards hot spots.
DYH-Tungsten-Halogen	600	3200°K (type–B)	75 hrs.	

*Color temperature drops as bulbs age. This problem can become critical after bulb has been used for one-half of its life span. If color matching is important, use only for first third of the stated life span, or use tungsten-halogen bulbs.

lent for bouncing or umbrella use, but somewhat inefficient for direct light, as they tend to project a "hot spot" from the center of the bulb, creating a kind of partial spotlight effect. Sealed-beam bulbs do not require reflectors. The reflectors are built in.

Tungsten-halogen bulbs come in the form of relatively small bulbs in many different shapes, and with many different connectors, none of which is of the household, screw-base variety. Both 3200°K and 3400° bulbs are available, as are bulbs of other lower color temperatures. Unlike tungsten bulbs, they do not drop in color temperature as they age, but retain their designated color for the life of the bulb. This makes tungsten-halogen the best bet where absolute color fidelity is required, such as copying paintings, etc. Watt for watt, however, they are more expensive than tungsten bulbs, and far more fragile. Because of their small size, they must be mounted in reflectors specifically designed for them in order to prevent hot spots when used as direct light sources.

Light Stands

Light stands are usually made of aluminum with telescoping sections and three folding legs. It is not the purpose of this book to recommend specific brands, but in this case the author feels a duty to his readership to recommend PIC light stands. There is nothing more frustrating than a simple device that has a tendency to fall apart in your hands. PICs don't. Enough said.

Conventional Lighting

Conventional lighting is built around the triumvirate of key light, fill light, and backlight.

The primary lighting tool is the key light. The key light determines the light direction and the subject modeling. Except in special circumstances, it is usually placed on one side of the camera, and within an 85° angle from the subject. It can be a flood or a spot, but in either case *it* determines the exposure. To

keep wall and floor shadows at a minimum, the key should be as high as possible, but watch out for eye-socket shadows.

A fill light is usually placed on the other side of, but close to, the camera. Its function is to provide fill-in light for the key. A backlight is placed behind the subject, high and out of the frame in order to separate it from the background and sometimes even create a rim-lighting effect. Additional lights, usually floods, can be used to light the background, etc. For dramatic effects, the key light can be moved farther to the side, the backlight increased in intensity, or the fill light brought down in intensity. All, or any combination of the above, can be used for dramatic effect.

When photographing large interiors, care must be taken to match your lighting with the light fixtures and other light sources in the scene. If there is a lamp or other lighting fixture in the frame, it is usually necessary to key a light from the same angle. If this is too difficult, or even impossible to accomplish with the key light, a secondary key should be used. A narrow flood or spot should be placed out of the frame on the same axis as the lamp or fixture. Its ratio with the primary key, when read in the immediate vicinity of the lamp or fixture, should be on the order of 1 to 1. Another means of accomplishing the same thing is to replace the low-output light bulbs in the lamp or fixture with a 300- or 500-watt bulb. Your eye will tell you which to use.

Initially, however, I suggest that you keep your lighting as simple as possible. Work with as few lights as you can get by with, and watch out for shadows on walls and floors, as they can cause no end of problems. Multiple shadows are particularly bad and difficult to deal with.

To help control shadows and light spill, you can easily make a "cookie," which is nothing more than a piece of dark cardboard, cut to suit the situation, and placed in front of the light so as to shield specific areas. Cookies are easily attached to light stands with clamps or tape.

Diffusers are used to cut down and soften the light from any given source. Mount diffusers a few inches in front of the light, and keep in mind that photographic lights give off a great amount

of heat. A flammable material used as a diffuser is likely to result in a three-alarm fire.

Diffusers work well for softening light. When used over a key light, they lower the amount of fill necessary and soften hard shadow lines.

"Barn doors" are devices that attach to most photographic lights in order to restrict the light spread. They consist of two or four black metal shields hinged like doors, hence the name.

Bounce Light

Still photographers claim they invented bounce lights. Whether or not their claim is justified, bounce light is an ingenious way of solving innumerable problems. It can be used as a main or a key light, a fill light, or an overall flat lighting source. In fact, occasionally, when you are dealing with relatively simple situations, one light judiciously bounced can serve all three of the above functions simultaneously.

When bouncing a light off a wall or a ceiling, you can expect a loss of intensity. The surface against which the light is being bounced will absorb a portion of it, and the remainder of the light loss will be due to dispersion. However, a few bounce lights can serve the same needs as a battery of direct lights.

Bounce lighting is accomplished by pointing lights at the walls or the ceiling. In a pinch, when shooting indoor documentaries, you can even use a camera-mounted light pointed upward, in bounce position. Because of the resultant dispersion, bounce light provides its own fill.

A colored wall, painted blue, for example, will reflect blue light; therefore, make sure that the walls and ceilings you are bouncing against are white. Actually, a pure white is hard to come by, as professional house painters have a tendency to mix a little colored pigment into their white paint. To compound the error, white paint also has a tendency to age toward yellow. Therefore, your bounce light is going to be slightly on the "warm" side, a yellow or orange-red. This is not as bad as it sounds, as the

slight warming of flesh tones that results can be quite pleasant. If necessary, a 72-A or 72-B filter can be used.

If your lights are rated at 3400°K and you are using Ekta-chrome, Type B film, the relative coldness of the light source should be adequate to compensate for the moderate color shift encountered when bouncing off most "white" walls.

If and when you come up against chartreuse walls and fuchsia ceilings, don't despair. You can make your own white walls and ceilings. All you need do is hang a white sheet against the wall. For ceilings, white cardboard or aluminum foil works fine, with the dull side of the foil facing the light. When taping up your substitute "walls," beware of tape that might peel the paint or plaster.

When bouncing, the closer the light to the reflecting surface, the more direct or "hard" will be the resultant lighting. Conversely, the farther the light from the reflecting surface, the softer and more diffused the resultant lighting. Brightness can also be controlled in this manner. However, a minimum of at least 2 feet between light source and reflecting surface when using incandescent lights is necessary to keep from burning the house down. Flash, of course, presents no such danger.

Corners, where walls and ceilings meet, are very efficient reflectors for bounce lighting. They have a tendency to bounce lights into a room in a somewhat tighter pattern than can be obtained from a flat wall surface.

Unless you are attempting to fill an area near the floor, your wall bounce-light source should be set well above eye level. Care should always be taken that direct spill from the light source does not fall on the scene, as this would defeat the entire purpose of bounce light.

Umbrella Light

Still another technique we have to thank still photographers for is the use of white umbrellas for bounce lighting. Umbrellas ranging in size from about 18 inches to about 36 inches are

available, with the necessary fittings, from the lighting departments of large camera shops. When mounted on a light stand, they serve as portable bounce surfaces and can be raised, lowered, or tilted. A light is mounted directly onto the umbrella shaft or light stand and directed toward the center of the umbrella. The resultant light is similar to that obtained from wall bounce, except that it can be directed where you want it. Another difference is that umbrella light has the tendency to be somewhat less diffused than wall bounce. This can be an advantage in that more light will fall on the subject. The basic reason for umbrella light: *soft lighting.*

Any number of umbrellas can be used in combination with wall and ceiling bounce. They can even be used as overall fill for direct key-lighting. The closer the umbrella is to the subject, the softer the light. For this reason, large white umbrellas are recommended; *silvered umbrellas are not.*

Electrical Power

The maximum amount of light you can throw on a scene is in direct proportion to the amount or amperage of electrical power available on the premises. The fuse or the circuit-breaker box can give you this information. If there is more than one fuse or circuit breaker, this indicates that there is more than one line. If so, you are in luck, but first you must determine which line feeds which outlets. It's a simple matter to pull the fuse on each line, and observe which outlets become inactive. This done, you can now split your power requirements between the lines available to you.

To determine the power requirements of your lighting equipment, divide 100 into the rated wattage. Thus, a 500-watt light will draw about 5 amps (this is a rule-of-thumb formula, so allow some leeway). For example, if the rated amperage of the available line is 15 amps, you can use three 500-watt bulbs— provided you turn off all room lights and electrical appliances.

Chapter Sixteen

SHOOTING IN LOW LIGHT

There are many situations where the light level is low, barely sufficient for photography without the addition of photographic light (flash, etc.) or special techniques. This chapter deals with "special techniques."

Under normal circumstances, using standard film with no special processing and lenses rated at $f/2$ or faster, the lowest practical light level for the handheld camera is about 8 foot-candles (86.08 lux units), or at ASA-400 (Tri-X) an exposure of $f/2$ and 1/30 sec. That is approximately the amount of light one could expect from a bare 40-watt light bulb at about 5 feet from the subject. Put another way, it is an amount of light barely sufficient for comfortable reading. It represents the absolute limit for *normal* photographic applications without the use of a tripod on which to mount the camera and thus permit longer exposures. Of course it is possible to handhold a 35mm camera, mounting a normal or wide-angle lens at shutter speeds of 1/15 sec., and even slower, but it is not recommended as standard practice.

Available-Light Photography

The 35mm camera in its early days was thought of as a "candid camera." With its inception, it became easier to photograph people in "candid" situations, to produce photographs

taken under adverse lighting conditions which hitherto only a very few photographers had been able to cope with. The idea was to show the world as it actually existed, in its own light, undisturbed by the distortional glare of flash or other artificial-looking photographic lighting. Photographers, no longer restricted to the great outdoors, or to the use of flash or flash powder or heavy tungsten lights, could move indoors and operate with freedom to create photographs that conveyed the total ambience of time place. The people in such photographs usually seem unaware of the camera (except in cases of environmental portraits), because the photographer, unencumbered by paraphernalia, is unobtrusive—eventually people begin to accept him as *belonging*.

In photographic parlance, the term *"available light"* refers to the light that normally exists in many types of situations. It does not refer to broad daylight, or photographic lighting. Available light is all the light that normally exists in urban living rooms and peasant shacks. It is the light that is *available* in bars and cathedrals and sports palaces and prisons and on dimly lit streets. It is quite often barely sufficient for photography, a fact that has deterred very few talented photographers dedicated to the interpretation of reality.

The 35mm camera, particularly the 35mm rangefinder camera, with its quiet shutter and ease of focusing in dim light, is particularly suited to the task. It is in this type of photography where the small format camera comes into its own, and it might be added that the bugaboo of 35 photography—*grain*—actually is turned into an advantage. People down through the years have come to associate grain with candid realism. They assume that a *"grainy"* documentary film or a grainy documentary photograph somehow conveys "truth" and graphic reality. Grain, too, is an ambience—there is no reason to fear it or fret about it in available-light situations, particularly those that involve social documentation.

In this chapter and others the reader will find most of the data he needs in order to operate efficiently in any kind of available-

light situation. He must learn how to deal with slow shuttter speeds and wide apertures, how to hold the camera steady, and filter its lenses against a variety of aberrant light sources.

"Pushing"

Pushing is a term used to define an increase in rated film sensitivity brought about by an increase in film development time. In many low-light situations it is the only expediency available to the photographer.

Let's face it, there are time when even the fastest films are not sensitive enough to produce adequately exposed photographs with a handheld camera (situations that preclude the use of a tripod). There are times when the slow shutter speed called for by inadequate light may not be fast enough to freeze the action at sporting events, or circuses, or outdoors at night, etc. Then there are those situations that call for the use of handheld telephoto lenses, which have smaller maximum apertures and require even faster shutter speeds in the bargain. (Keep in mind that any long lens is an *optical lever;* a slight amount of camera movement at the camera end produces much more at the optical end. Thus the need for a faster shutter speed than with a shorter lens.)

Color films may be safely pushed as much as one and a half stops, or 3X. For example, Kodak High-Speed Ektachrome, Type B, rated as ASA-125 \times 3 = E.I. 375, a sensitivity increase of one and a half stops. Black and white film, under some circumstances, may be pushed/processed to an even greater extent.

To push or increase the exposure index of a film, the photographer must first decide on the new exposure index, and enter it on the ASA setting of his exposure meter. After exposure, the film can be processed by the user, according to Appendix Four (or data supplied by the film or chemistry manufacturer), or it can be sent to a professional processing laboratory along with the data concerning the film's exposure index. If lab processing

is to be used, the photographer should consult with the laboratory *before* shooting in order to be sure that push-processing services are available. They usually are at independent professional labs in large cities.

In addition to independent laboratories, Eastman Kodak and GAF also provide push services for their films. Kodak High-Speed Ektachrome will be processed at a one-and-a-half stop increase (3X) by Kodak through the use of a special mailer obtainable at your local Kodak dealer. GAF supplies a service for push-processing their GAF-200 and GAF-500 color transparency films to a plus one stop (2X).

Pushing black and white film is a somewhat more complex matter, due to the fact that there are more possible variations. In addition, black and white film takes to push processing with considerably less grace than does color, particularly in contrasty lighting situations. The reason for this is that the shadow areas on the black and white *negative* are those areas of the negative with the least density. In a contrasty lighting situation, shadow areas, unless exposed adequately, may lack density to such an extent that they consist of little more than clear film. In that case, extended development, or pushing, *will have little effect on film density that doesn't exist*—this, combined with the fact that film development is more active in dense areas of the negative, will usually result in nothing more than an increased buildup of highlights, and little if any increase in the shadow or dark areas of the negative which, in low-light situations, is usually important. What all this boils down to is that an attempt to increase the exposure index of black and white film will sometimes result in nothing more than an increase in contrast and graininess. It is advisable not to attempt a radical increase in film speed when shooting black and white film in any situation where the brightness range exceeds 4 to 1. Like all rules, this one, too, can be broken, but only if you know why you are breaking it . . . in this case it would be in order to create extremely high-contrast images that often are startlingly graphic.

Color film, when pushed, deals with contrast somewhat more

tolerantly. Unlike black and white film, the shadow, or dark areas of the scene, are represented on the color transparency film as density—it is the highlights which tend to be clear. Therefore, when color film is pushed there is rapid buildup of additional density in the *shadow areas,* and a relatively *slow* buildup of highlight density. Contrast is therefore not a major problem with extended development of color transparency film. It must be reiterated, however, that in contrasty shooting situations, despite the fact that an increased exposure index is being used, the exposure calculation should be based on highlights—the rule still stands.

I advise one and all not to exceed one and a half stops (3X) when push-processing color film of any kind. The speed limit is imposed because beyond a 3X extension in film speed lies the imminent danger of reduced *maximum density* and possible color shifts too aberrant to deal with, or even to predict. As explained earlier in this book, maximum density (or D-max) refers to the density of the deepest blacks in any color transparency. A low D-max is indicated by blacks that appear to be an ugly, translucent green or brown instead of rich, opaque black.

If the reader finds it necessary to extend color pushing beyond 3X, he is, of course, free to try. There have been many cases where such extensions have been successful. The problem is one of consistency; some film emulsion batches might conceivably lend themselves to as much as a 6X increase. The photographer who tries it and is blessed with success is most certainly going to be bitterly disappointed when he tries again a month later with film of another emulsion number.

Tripods

In low-light situations, the tripod can be the photographer's best friend. With the camera mounted securely on a tripod, shutter speeds of indeterminate length are possible without fear of camera movement.

Tripods are also necessary for telephoto lenses with focal

lengths exceeding 400mm. Such lenses are, for all practical purposes, impossible to hold steady, even at the fastest shutter speeds.

The heavier the tripod, the more unshakable it is as a camera platform. Lightweight tripods, though more portable, are somewhat less secure, though a lightweight tripod parlayed with a heavy camera such as the Canon is more viable than the same tripod mounting a lightweight camera such as the Olympus. In either case, it may be advisable to release the shutter via the self-timer, as even the action of a cable release might jolt the camera. Under any circumstances, the photographer should wait at least a dozen seconds after winding the film to allow residual movements to quiet down. This is particularly true when the tripod centerpole is extended, as it may have the tendency to vibrate for at least a few seconds after the camera is handled.

The disadvantages of tripods are two in number: they are bulky and the best of them are somewhat difficult to carry around; secondly, they are somewhat restrictive of rapid camera movements. Nevertheless, they are indispensable in many situations, and if used properly they guarantee photographs unmarred by camera blur.

Mirror Lockup and Cable Releases

On many 35mm reflex cameras there is a device whereby the mirror can be locked into the retracted position. Despite sophisticated damping mechanisms on better cameras, mirror "slap" can still be a problem in some circumstances, causing an almost imperceptible jolt that can result in a blurred image. I recommend locking up the mirror in all situations where the shutter speed ranges between 1/15 sec. and 1 sec., with lenses exceeding 135mm. With focal lengths of from 300 to 500, the mirror should be locked up for anything longer than 1/60 sec. When using lenses longer than 500mm, a locked-up mirror is a necessity at any shutter speed. (It is assumed that in all the above cases a tripod or other camera support is being used.)

The general procedure is to focus and frame the subject, lock up the mirror, and shoot. As long as the camera is not moved or the focusing ring untouched, as many frames as desired can be squeezed off without the necessity of checking the viewfinder (providing the subject is static, of course).

The cable release is a device that screws into a socket usually found atop the shutter release button. Its function is to provide a jolt-free method of releasing the shutter without the necessity of actually touching the camera. It should be used whenever the camera is mounted on a tripod or any other type of camera support.

Bracing the Camera

In terms of expediency, it is possible to prefocus the camera and jam it tightly against a wall, aiming it solely by guesswork. Wide-angle lenses, producing small image sizes and relatively long depths of field, work best in this application. To keep from jolting the camera, a cable release or shutter tripping via the self-timer is recommended. Another expediency is to prefocus and set the camera on a table, pointed in the right direction. Once again, a cable release or self-timer is recommended. The camera can also, through the use of a photo clamp, be attached to a chair or doorjamb or similar structure. In this case, it is possible to focus and sight properly, and if firmly clamped, even telephoto lenses can be used.

The idea is to extend shutter speeds and thus increase the basic exposure. However, even though you might be holding the camera steady enough to overcome camera movement at these low speeds, you still might have a problem with subject movement or blur. Everything in photography has its price.

filters for black/white film

FILTER NO.	COLOR OR NAME	SUGGESTED USES
6	Yellow 1	For all black and white films, absorbs excess blue, outdoors, thereby darkening sky slightly, emphasizing the clouds.
8	Yellow 2	For all black and white films, most accurate tonal correction outdoors with panchromatic films. Produces greater contrast in clouds against blue skies, and foliage. Can be used for special effects with color film
9	Yellow 3	Deep Yellow for stronger cloud contrast
11	Green 1	For all pan films. Ideal outdoor filter where more pleasing flesh tones are desired in portraits against the sky than can be obtained with yellow filter. Also renders beautiful black and white photos of landscapes, flowers, blossoms and natural sky appearance
12	Yellow	"Minus blue" cuts haze in aerial work, excess blue of full moon in astrophotography. Recommended as basic filter for use with Kodak Aero Ektachrome Infrared.
13	Green 2	For male portraits in tungsten light, renders flesh tones deep, swarthy. Lightens foliage, with pan film only.
15	Deep Yellow	For all black and white films. Renders dramatic dark skies, marine scenes; aerial photography. Contrast in copying
16	Orange	Deeper than #15. With pan film only
21	Orange	Absorbs blues and blue-greens. Renders blue tones darker such as marine scenes. With pan film only
23A	Light Red	Contrast effects, darkens sky and water, architectural photography. Not recommended for flesh tones. With pan film only
25A	Red 1	Use with pan films to create dramatic sky effects, simulated "moonlight" scenes in mid-day (by slight under-exposure). Excellent copying filter for blueprints. Use with infra-red film for extreme contrast in sky, turns foliage white, cuts through fog, haze and mist. Used in scientific photography
29	Dark Red	For strong contrasts; copying blueprints
47	Dark Blue	Accentuates haze and fog. Used for dye transfer and contrast effects
47B	Dark Blue	Lightens same color for detail
56	Light Green	Darkens sky, good flesh tones. With pan film only
58	Dark Green	Contrast effects in Microscopy, produces very light foliage
61	Dark Green	Extreme lightening of foliage
87		For infra-red film only, no visual transmission
87C		For infra-red film only, no visual transmission
Neutral Density	All Film Types Color or Black and White	For uniform reduction of light with high-speed films for still and movie cameras. No change of color value
Polarizer	All Film Types Color or Black and White	Eliminates surface reflections, unwanted glare or hot spots from any light source. The only filter that will darken a blue sky and increase color saturation.

Tiffen Optical Co.

filters for color film

FILTER NO.	SUGGESTED USES
CLEAR	Optical glass lens protection with no color shift
SKY 1A	Use at all times, outdoors, to reduce blue and add warmth to scene. Also in open shade
HAZE 1	Reduce excess blue caused by haze and ultra-violet rays. Ideal for mountain, aerial and marine scenes
HAZE 2A	Greater ultra-violet correction than Haze #1 filter and adds some warmth to the visible colors
UV15	Haze filter, also for Anscochrome 3200°K film with photofloods
UV16	Reduces excessive blue in electronic flash, also may be used for haze correction
UV17	Greater haze correction, reduces blue in shade
80A	Converts daylight film for use with 3200°K lamps
80B	Converts daylight film for use with 3400°K flood
80C	For use with clear flash and daylight color films.
81	Yellowish, warming filter
81A	Balances daylight films to electronic flash. Corrects Type B films for use with 3400°K lamps. Prevents excessive blue
81B	Warmer results than 81A
81C	Permits the use of clear flash lamps.
81D	Permits the use of clear flash except SM or SF. Will render warmer results than #81C filter
82	For any 100° increase in Kelvin temperature for color renderings.
82A	With Daylight and Daylight Negative films use in early AM or late PM to reduce the excessive red of the light. When using Type A (3400°K) films under 3200°K lamps.
82B	For cooler results
82C	For cooler results or when using 3200°K lamps
85	Converts Type A film to Daylight.
85B	Converts Type B film to daylight.
85C	Helps prevent overexposure of blue record layer.
CC30R	For under water photography, to correct color. Also, to compensate for distortion of color when shooting through transparent plastic windows similar to vistadomes provided by railroads for camera fans
FLB / FLD	Eliminates the deep blue-green cast ordinarily resultant from shooting color films with fluorescent lights. FLB Type B Films FLD Daylight Films
Neutral Density	For uniform reduction of light with high-speed films for still and movie cameras. No change of color value.
Polarizer	Eliminates surface reflections, unwanted glare or hot spots from any light source. The only filter that will darken a blue sky and increase color saturation.

Tiffen Optical Co.

Chapter Seventeen

FILTERS

Photographic filters for use with still cameras come in the form of optical-glass disks and squares of gelatin (plastic). The disks are screwed into, or otherwise attached to, camera lenses. Gelatin filters are attached with special mounts made for the purpose, or as an expediency may be held in front of or even taped to the lens mount. (Never to the glass surface of the lens itself!) Light passing through the filter is therefore modified in terms of color before striking the film. All filters, because of their densities, result in some degree of light loss.

Conversion Filters, 85 (85A) and 85B

When using Type A Kodachrome, a film meant for exposure under tungsten (incandescent) light, an 85 filter is required for using the film outdoors in daylight. Ektachrome Type B, under the same circumstances, requires an 85B filter.

The primary advantage of using tungsten film outdoors with a conversion filter is that only one type of film need be stocked or carried. A conversion filter obviates the necessity to switch a partially used cartridge when you are moving from a daylight to a tungsten situation, and vice versa.

Conversion filter 85 (85A) and 85B can also be used in *black and white* photography, though their function has nothing to do

165

with "conversion." Because of their "orange" color,* these filters absorb blues and greens, rendering them darker. They are excellent for darkening sky and water and emphasizing clouds and spectral reflections. They are not recommended for flesh tones.

Haze and Skylight Filters

These are used to reduce the excess blue, usually caused by ultraviolet, in haze and open shade. A haze #1 or #2 filter is recommended for landscapes. For open-shade photography, a skylight or sky-1A filter is recommended. For additional ultraviolet correction with color or black and white films, refer to the charts on pages 162-63.

Neutral-Density Filters

A neutral-density filter imparts no color or color shift to the film. It is gray. Its purpose is to absorb or cut down the amount of light passing through the lens onto the film. This function is advantageous when the photographer wishes to use a wider aperture to cut his depth of field. It is also handy when the minimum aperture of the lens in use is not small enough to equate with a desired slow shutter speed. They come in a variety of densities, and may be used with color or black and white film.

Polarizers

Polarizers eliminate surface reflection in many situations. A polarizer will also darken a blue sky and is ideal for use with color films, as it imparts no color shift of its own. Polarizers can also double in brass as neutral-density filters, and can be used with color or black and white film.

Star Filters

Star filters are used to create starlike patterns in highlights.

* "Orange-" or salmon-colored 85 and 85B filters combine *subtractives* yellow and magenta. Again, yellow is minus blue; magenta is minus green.

GENERAL EFFECT OF RED, BLUE GREEN AND YELLOW FILTERS
ON BLACK AND WHITE PANCHROMATIC FILM

Subject—Color	red filter	blue filter	green filter	yellow filter
blue-green (cyan)	DE	DS	DS	D
blue	DE	L	DE	DE
green	DE	DE	L	LS
red-blue (magenta)	DS	DS	DE	D
red	L	DE	DE	LS
yellow	DS	DE	DS	L

Code: D — Darken
DS — Darken Slightly
DE — Darken Extensively
L — Lighten
LS — Lighten Slightly

These special-effects filters are most effective when lights or spectral reflections are in the picture. They come in three star sizes, from 1mm to 3mm, and may be used in combination for black and white or color. They are a touch of fantasy, particularly where streetlights appear in the scene.

Fog Filters

Fog filters are used for fog effects. Fog filters are of neutral color and come in four densities for color or black and white film. When used properly, they are quite capable of simulating or exaggerating actual fog. Some manufacturers also make fog-effect filters that cover only half the disk and can be used to simulate fog on the upper or lower half of the frame. Since their purpose is to create or heighten the effect of a foggy day, they should never be used in sunlit conditions, as the results would appear artificial.

Neutral Density Filters for all film.

Neutral Density filters allow the photographer to control high-speed films by reducing the intensity of the light transmitted, without changing the color quality of the light. Series 5, 6, 7, 8 and 9. Screw-In No. .3, .6 and .9 only 43 through 82mm.

Series 5 available in .3, .6, .9 only.

Tiffen Neutral Density	% Light Transmission	Increase in Stops
ND 0.1	80	1/2
ND 0.2	63	3/4
ND 0.3	50	1
ND 0.4	40	1-1/4
ND 0.5	32	1-3/4
ND 0.6	25	2
ND 0.7	20	2-1/4
ND 0.8	16	2-3/4
ND 0.9	13	3
ND 1.0	10	3-1/4
ND 1.2	6.3	3-3/4
ND 1.5	3.2	4-1/4
ND 2.0	1.0	6-2/3
ND 3.0	0.10	10
ND 4.0	0.001	13-1/3

2) and this is stop for correct exposure	1) If smallest marked stop is . . .		
	f/16	f/22	f/32
	3) then use ND filter:		
f/22	ND .3	none	none (use f/22)
f/32	ND .6	ND .3	none
f/45	ND .9	ND .6	ND .3
f/64	ND 1.2	ND .9	ND .6
f/90	ND 1.5	ND 1.2	ND .9
f/128	ND 1.8	ND 1.5	ND 1.2
f/180	ND 2.1	ND 1.8	ND 1.5
f/256	ND 2.4	ND 2.1	ND 1.8

2) but this aperture is needed	1) If this is desired aperture for selective focus				
	f/5.6	f/4	f/2.8	f/2	f/1.4
	3) use these Tiffen ND filters				
f/8	ND .3	ND .6	ND .9	ND 1.2	ND 1.5
f/11	ND .6	ND .9	ND 1.2	ND 1.5	ND 1.8
f/16	ND .9	ND 1.2	ND 1.5	ND 1.8	ND 2.1
f/22	ND 1.2	ND 1.5	ND 1.8	ND 2.1	
f/32	ND 1.5	ND 1.8	ND 2.1		

Tiffen Optical Co.

KODAK Color Compensating Filters

Peak Density	Yellow (Absorbs Blue)	Exposure Increase in Stops	Magenta (Absorbs Green)	Exposure Increase in Stops	Cyan† (Absorbs Red)	Exposure Increase in Stops
.025	CC025Y	—	CC025M	—	CC025C	—
.05	CC05Y	—	CC05M‡	⅓	CC05C	⅓
.10	CC10Y	⅓	CC10M‡	⅓	CC10C	⅓
.20	CC20Y	⅓	CC20M‡	⅓	CC20C	⅓
.30	CC30Y	⅓	CC30M	⅔	CC30C	⅔
.40	CC40Y·	⅓	CC40M‡	⅔	CC40C·	⅔
.50	CC50Y	⅔	CC50M	⅔	CC50C	1

Peak Density	Red (Absorbs Blue and Green)	Exposure Increase in Stops	Green (Absorbs Blue and Red)	Exposure Increase in Stops	Blue (Absorbs Red and Green)	Exposure Increase in Stops
.025	CC025R	—	—	—	—	—
.05	CC05R	⅓	CC05G	⅓	CC05B	⅓
.10	CC10R	⅓	CC10G	⅓	CC10B	⅓
.20	CC20R	⅓	CC20G	⅓	CC20B	⅔
.30	CC30R	⅔	CC30G	⅔	CC30B	⅔
.40	CC40R	⅔	CC40G	⅔	CC40B	1
.50	CC50R	1	CC50G	1	CC50B	1⅓

Eastman Kodak

Color-Compensation Filters

CC filters come in several densities in each of the primary colors: red, blue, and green (additive primaries); and the subtractive colors: magenta, cyan, and yellow. In use, subtractive CC filters may be combined to create almost any conceivable tint.* These filters are available in gelatin and are quite inexpensive. Photo dealers also carry inexpensive gelatin-filter holders, which further simplify their use. Care must be taken to preserve their surfaces. Beware of even less expensive color printing (CP) filters in acetate form, as they are not made to be used with cameras and may degrade or diffuse the image. CC filters are made for color films but may be used to change tonal relationships in black and white.

* Additive filters are never combined with each other. No more than two subtractive filters may be combined.

Soft-Focus or Diffusing Filters

Soft-focus filters blend shadows and create a halo effect in highlight areas. They minimize blemishes and rough skin texture in closeups, and they diffuse and soften backgrounds. They impart a feeling of luminosity and are especially significant in side- and backlit scenes. The effect is created by dispersal of highlights into the shadow areas by means of light diffraction. They are used for nudes, scenics, night scenes, portraits, etc. Soft-focus filters come in two types: random and concentric. The random type retains the same degree of diffusion regardless of *f*/stop. The concentric type varies the amount of diffusion relative to lens aperture. Either type may be used with color or black and white film.

Fluorescent Filters

Fluorescent light has a *discontinuous spectrum* in which the green wavelengths predominate. The degree to which this is the case relates to the type of tube. Some tubes display an almost total lack of red. This can create a large problem with color film.

Eastman Kodak recommends specific filter combinations for specific types of tube (detailed information follows), but usually the photographer does not have time to ascertain the tube type and then run out to purchase the filters. Therefore, my recommendation is as follows: for use with Type B film—an FLB filter, which absorbs green and blue. For use with daylight film—either a CC-30M or an FLD filter, both of which absorb green. The above recommendations are admittedly expedients, but they will put you in the ball park for all except blue-daylight fluorescent tubes and tubes made specifically for photography, which require no filtration (and are extremely rare). For further details, and extensive data on other filters, see charts that follow. Fluorescent light, when used with black and white film, requires no filtration except in cases where accurate tonal relationships are important. In such cases, use the fluorescent filters recommended for daylight color films.

A GUIDE TO THE USE OF COLOR CONVERSION AND LIGHT BALANCING FILTERS FOR COLOR FILMS

> Lay a straight edge between film type and light source. Such a line will bisect the filter scale, indicating the correct filter. Sample line recommends an 80B filter for daylight film in 3400°K light.

FILM KELVIN TEMP. RATING

Daylight film ★ 5500°K

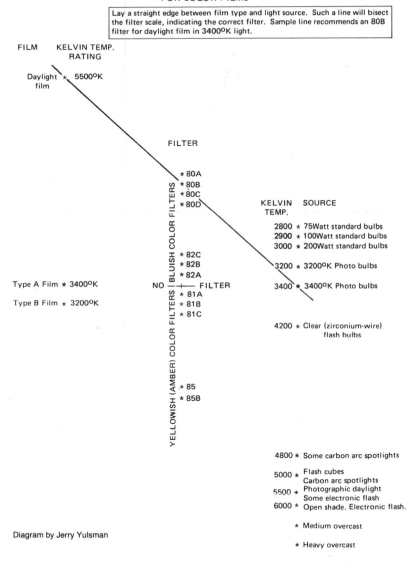

FILTER

BLUISH COLOR FILTERS
★ 80A
★ 80B
★ 80C
★ 80D

KELVIN TEMP. SOURCE

2800 ★ 75Watt standard bulbs
2900 ★ 100Watt standard bulbs
3000 ★ 200Watt standard bulbs

3200 ★ 3200°K Photo bulbs

★ 82C
★ 82B
★ 82A

Type A Film ★ 3400°K NO —+— FILTER 3400 ★ 3400°K Photo bulbs

Type B Film ★ 3200°K ★ 81A
 ★ 81B
 ★ 81C

4200 ★ Clear (zirconium-wire) flash bulbs

YELLOWISH (AMBER) COLOR FILTERS
★ 85
★ 85B

4800 ★ Some carbon arc spotlights

5000 ★ Flash cubes
 Carbon arc spotlights
5500 ★ Photographic daylight
 Some electronic flash
6000 ★ Open shade. Electronic flash.

★ Medium overcast

Diagram by Jerry Yulsman

★ Heavy overcast

FILTRATION SUGGESTIONS FOR CORRECTION AND ENHANCEMENT OF BLACK AND WHITE FILM

If Your Subject Is:	And You Desire:	Filter With:
Landscapes	haze	none
	haze rendition	# 8
	less haze	#15
	considerable haze reduction	#20 or #25
Seascapes (Blue Sky)	natural looking tones	# 8
	dark water	#15
Blue Sky	natural looking tones	# 8
	darkened	#15
	dramatically darkened	#25
	extremely darkened	#29
	nighttime simulation	#29 plus polarizer
	white, featureless	#47B
People Against Blue Sky. (Portraits, Nudes, Etc.)	natural sky, with enhanced and pleasing flesh tones.	#11 or #8
	Same as above but with "normal" flesh tones.	polarizer
Foliage, Flora.	normal looking tones	#8 or #11
	lighter tones	#58
Sunsets, Sunrises.	normal tones	none
	slightly enhanced	# 8
	exaggerated brilliance	#15 or #25
	haze enhancement for atmospheric effect	#47
Warm Colors, Copper, Bronze, Oranges, Reds, Etc.	to lighten so as to show detail	#25
Sand, Snow, Stone, Concrete, Wood. (Sunlit)	texture and detail	#15 or #25
Male Portraits	to create a swarthy and rugged effect (Caucasian only)	#11 or #13

Chapter Eighteen

ELECTRONIC FLASH

Electronic flash is the photographer's most portable light source. Ounce for ounce, the electronic flash, or "strobe," as it is sometimes called, puts out more light than any other means of lighting. In fact, it dwarfs all other photographic light sources in terms of sheer power. Think of it—a tiny device that will fit in the palm of your hand, capable of lighting an entire room! It does this through the use of an energy-storing device called a capacitor.

The Capacitor

The *capacitor* is charged electrically from a battery or house current. When it is fully charged, or "cycled," all the energy it has stored can be released in a tiny fraction of a second into a flash tube which transforms this sudden jolt of electrical power into light. The larger the capacitor, the greater the amount of light.

The capacitor is usually discharged through the camera's shutter release by means of a "sync cord" or wire connecting it to the flash unit.

Recycling Time

The time it takes for the capacitor to store up sufficient energy after it has been discharged is known as the recycling time. This

varies from unit to unit and is also relative to the kind of power source used to charge it up. When the flash unit is once again ready to be fired, a recycling light, or signal is initiated in order to inform the photographer.

Power Sources

Portable strobe units operate on batteries, non-portable units and large studio strobes are powered by AC current. (Most of the available larger portable units will also operate on AC.) Let's deal with the various types of batteries:

Alkaline Cells

These batteries are usually of the penlight, or AA size. They are used in strobe units in groups of two or three, depending on the size of the unit. When fresh, they provide recycling times of between 5 and 15 seconds, depending on the type or brand of the flash unit.

Advantages: Many units made to take AA cells are quite inexpensive. Alkaline AA cells provide a reasonably fast recycling time. Batteries are readily available almost anywhere, and are of a type used in flashlights and transistor radios. It is quite easy to carry around spares.

Disadvantages: Alkaline AA cells are expensive when one considers the fact that their average life is from thirty-five to a hundred flashes, depending on type and brand of flash. For the photographer who uses flash only occasionally, shelf life must also be considered—like all batteries, alkaline batteries have a tendency to lose their potency when stored for a length of time.

Nickel-Cadmium Cells

These batteries, unlike alkaline cells, are rechargeable. Flash units made to take nickel-cadmium cells provide recharging facilities, some within the unit itself and some through the use of an external charger. Externally charged units offer the option of using more than one set of batteries—one set charging while the

other is busy powering the strobe unit. Some flash units that charge their cells internally have removable batteries also, while others have their cells permanently sealed within the unit itself. Sealed-battery units are not recommended, as a fully charged nickel-cadmium cell provides even fewer flashes than its comparable AA-alkaline cousin. If the exhausted nickel-cadmium cell cannot be replaced immediately with a standby, freshly charged cell, the photographer is likely to find himself lightless after little more than one roll of film.

Many units, provided by the manufacturer with AA-alkaline cells, can be converted to nickel-cadmium quite simply. Nickel-cadmium AA cells are available, along with a charger, for a reasonable price from many electronic and hi-fi shops.* With most electronic flash units originally powered by AA-alkaline cells, it is then a simple matter to replace the batteries with user-charged AA-nickel-cadmiums. Thus, the photographer has the option of using either type of battery and to precharge a few extra sets of nickel-cadmiums to carry as spares.

Advantages: Nickel-cadmiums are inexpensive, as they may be used again and again. In fact, they usually outlast the unit itself. Since the photographer has charged the batteries, he is not faced with the possibility of purchasing depleted alkaline cells which have sat on the dealer's shelf just a little too long.

Disadvantages: Despite the savings in batteries, units designed for nickel-cadmium use are initially more expensive, because of the battery-charging mechanisms. Nickel-cadmium batteries, even when fully charged, have a smaller capacity than alkaline cells and also take slightly longer to recycle the strobe unit. Those units with chargers built in are somewhat more bulky.

High-Voltage Batteries

Batteries of over 100 volts are considered high voltage. Prob-

* Try Radio Shack, 274 West 125 St., New York, N. Y. 10027, or Lafayette Radio Electronics, 111 Jericho Turnpike, Syosset, N. Y. 11791, both mail-order houses. AA chargers are also distributed by Sun Pack, a manufacturer of electronic flash.

ably the most popular is the 510-volt battery, usually contained in a small pack weighing about 1 pound complete with shoulder strap. In most cases, recycling is on the order of a second or two, and with an occasional rest, such batteries will fire a strobe unit over 1000X.

Advantages: Fast recycling and tremendous capacity.

Disadvantages: Bulk—something else to carry.

Output

The amount of light provided by electronic flash is more or less related to the physical size of the unit. Ministrobes, such as the Vivitar-50, which is half the size of a cigarette pack, will, at 10 feet, when used with a film rated ASA-64, provide enough light to shoot at $f/3.5$. The Vivitar-292, a unit roughly five times the size and weight, at the same distance and with the same film, will provide an exposure of $f/11$—over 8X more powerful. For many applications, however, sheer power is not necessarily the only criterion. Even with slow films, such as Kodachrome, a ministrobe can be quite satisfactory when used directly on the subject. (And where else can you get that much light for under fifteen bucks?) They are handy things indeed to keep at the bottom of your gadget bag for emergencies. Large portable units* are necessary for bounce and umbrella light and for lighting large areas. Since their output is relatively high, they enable the photographer to shoot at minimal $f/$stops, thus ensuring greater depth of field.

The size and output of any electronic flash are usually directly related to its price. At this writing, many of the most powerful portable units are available for around $100, give or take ten or twenty bucks, while tiny ministrobes are available, on sale,

* When we speak of "portable units" we refer to only those that are attachable to the 35mm camera and that can be carried comfortably in a reasonably sized gadget bag along with other photographic gear. Studio units are not within the province of our discussion.

for as low as $10. Of course, at this writing there is also a factor of galloping inflation to be considered.

There are a few different means by which flash output is rated: *watt seconds* relates to an electrical measurement, while *beam-candlepower-seconds* (BCPS) relates to the output in terms of light. The most powerful portable strobes available rarely top 100 watt-seconds, while the smallest can be as low as 10 watt-seconds. In terms of BCPS, the brightest units will rate as high as 8000 BCPS, and the smallest as low as 350 BCPS. In terms of exposure, this would mean that the smallest commercially available portable strobe unit would require an exposure of $f/2$ on Kodachrome 25 at 10 feet, while the largest would require an exposure of $f/11$. More about this shortly, but first it is necessary for the reader to understand flash exposure calculations.

Flash Exposure Calculation

Strobe exposure is not dependent on shutter speed. Since the flash itself is of very short duration, the only consideration in terms of exposure is the $f/$stop. All 35mm cameras have a flash synchronizing speed of between $1/60$ and $1/125$ sec. Your camera manual defines this for you, as does the shutter speed dial on your camera, which usually indicates the sync speed with a red numeral or an engraved "X". This means that any shutter speed faster than the sync speed will not synchronize the shutter with the flash, and when the flash discharges, the shutter will be partially closed, resulting in an image cut off on the finished picture. (This was explained in an earlier chapter.) Therefore, in terms of flash exposure, once you have set the shutter dial to the proper sync speed, all that is then required is to determine your $f/$stop.

There are a few ways to accomplish this:

Guide Numbers

Guide numbers for electronic flash units are a handy means

ELECTRONIC FLASH – GUIDE-NUMBERS
To determine exposure, divide by distance, in-feet.

BCPS	25	32	64	ASA 80* 100	160	200	400
8000	100	110	160	185	250	300	400
5600	85	95	130	160	210	250	340
4000	70	80	110	145	180	220	280
2800	60	65	95	125	150	180	240
2000	50	55	80	100	130	160	200
1400	40	50	65	80	110	130	170
1000	35	40	55	65	90	107	140
700	30	32	45	55	75	90	120
500	24	28	40	50	65	76	100
350	20	24	32	40	55	65	85

*E.I. for High Speed Ektachrome Type-B with 85B filter.

of determining exposure if one is reasonably good at quick long division. A guide number is the figure given for a particular strobe unit and a specific ASA index. For example, your unit might have a guide number of 170 for Tri-X (ASA-400). To determine exposure, you would divide the distance (in feet) from the flash to the subject, into the guide number. Thus, ASA-170 divided by 10 (feet) equals 17. The closest f/stop to 17 is f/16. Another example: the same flash unit would have a guide number of 65 for Ektochrome-X (ASA-64). Let us say the flash is 13 feet from the subject—65 divided by 13 equals 5. We know that f/5 is approximately a half stop between f/4 and f/5.6. Close enough. (Always use the nearest half stop.)

Guide numbers for many strobe units are found in the instructional manual for the unit or sometimes on a calculator dial on the back of the unit itself. If none is given for your unit, the following chart will be of help. You must, of course, first determine the BCPS of your unit, and if it is not listed in the specs in your instruction manual, it can be determined by asking your dealer or writing the distributor or manufacturer.

Key-Exposure System

This is a means of determining strobe exposure that is based on the fact that light diminishes to the square of the distance. Put simply, this means that if you double the light-to-subject distance, the exposure increase will be 4X, or two stops. For example, let us say that at 10 feet your exposure works out to *f*/8. Therefore, according to the formula, if you moved the strobe to 20 feet, the exposure would then be *f*/4. The following chart demonstrates this rule a little more graphically:

KEY
EXPOSURE

Exposure	*f*/22	*f*/11	*f*/8	*f*/5.6	*f*/4	*f*/2.8	*f*/2	*f*/1.4
Distance	2½ ft.	5ft.	7½ ft.	10ft.	15ft.	20ft.	30ft.	40ft.

"Distance" refers to light-to-subject distance. If the flash is being used *off the camera,* you must measure the distance from the light, not the camera.

The basic idea behind the key-exposure system is to arrive at the correct exposure on a standard transparency film of your choice, with the light 10 feet from the subject. Any film can be used, but I recommend Kodachome 64 because of its conservative ASA rating and its standardized processing.

Using your strobe, start with a midpoint exposure, say *f*/8, and make exposures in half-stop increments, both up and down the scale. The subject should be average, say a person wearing brightly colored clothing, or a book case, etc. Remember, you are dealing with a *target* 10 feet from the camera, not an entire room, or something seen in long perspective. In each photograph there should be a piece of paper, on which is printed boldly the *f*/stop you are using. This is for later identification when you view the transparencies. When viewing the resultant transparencies, choose carefully the ones that please you most—check for highlight detail and reasonable shadow detail. If the subject is a person, judge the skin tones carefully for faithful reproduction. When you

have made your decision as to the best transparency, note the *f*/stop. This is your key exposure.

Once you have arrived at the proper exposure for your strobe at a distance of 10 feet from the subject, everything else falls into place automatically. If you know the exposure for one film type at 10 feet, you can determine the exposure quite easily for the same film at any other practical distance. The chart below should make that easy.

Double the light-subject distance = +2 stops
Half the light-subject distance = −2 stops

An alternate way to figure it is to multiply or divide the *f*/stop by two, thus: Let us say that your key exposure for ASA-64 film is *f*/8 at 10 feet. At 5 feet the exposure would be *f*/8 × 2 = *f*/16. At 20 feet it would be *f*/8 ÷ 2 = *f*/4.

As you can see by the chart, if the distance is increased by only 1:5X, in other words, from, let us say, 10 feet to 15 feet, then the exposure is *increased only one stop*. If the light-subject distance is decreased from 10 feet to 7½ feet, the exposure is *reduced by only one stop*. Changes of less than 1.5X can be estimated, the film having enough latitude to cover errors of a half stop or less.

Once you know the key *f*/stop for a specific film type (ASA), it is simple to convert to any other film types or ASA index. If your key exposure is *f*/8 10 feet) for ASA-64, it will be *f*/11–*f*/16 for ASA-160, or one and a half stops less (approximately). It works out this way:

Original key, ASA-64 *f*/8 (10 ft.)
New key for ASA-160 *f*/13.5* (10 ft.) minus 1½ stops from
 original key exposure
New key for ASA-400 *f*/22 (10 ft.) minus 3 stops from
 original key exposure
New key for ASA-32 *f*/5.6 (10 ft.) plus 1 stop from
 original key exposure
New key for ASA-25 *f*/4.8† (10 ft.) plus 1½ stops from
 original key exposure

* Between *f*/11 and *f*/16. † Between *f*/4 and *f*/5.6.

Arriving at key exposures for various ASA ratings, as you can see, is simply a matter of relating the ASA change to the key f/stop. Note the degrees of exposure change on the right of the chart—they are fixed, no matter what your original key exposure works out to. Once you have arrived at key exposures for all types of film you expect to be using, type or print them on a small piece of paper and tape to the top of your flash unit. From that point on, it's simply a matter of applying the inverse-square-ratio law that we dealt with earlier, in order to determine exposure at various light-subject distances, with the film in use.

Exposure Calculator

Many portable units have an exposure calculation dial on the rear or side of the housing. Some of these calculators refer to guide numbers, others to actual recommended exposures at various distances and ASA indexes. However, in many cases they are inflated and not to be trusted. For some reason, many manufacturers tend to exaggerate the output of their products. I recommend a thorough test before placing credence in their recommendations.

Strobe Meters

All of the various methods described above to determine flash exposure depend on the photographer's ability to determine distance. Of course a good guess is usually adequate, due to the inherent exposure latitude of most film, and then, too, one can actually measure the distance if there is time.* Nevertheless, practice, as always, makes perfect. The strobe meter, however, requires no guesswork. Essentially, it is an exposure meter for flash. A few of the available models can be used either as incident or reflected meters (just as in real life). The rules that apply to regular light meters also apply to strobe meters. They are to be used in essentially the same way—both incident and

* The footage scales engraved on most lenses are usually not too useful, as they leave large gaps between markings. Also, shocking as it may sound, *many of them are not accurate.*

reflected. They are also keyed to a 40% gray, 18% reflectance. Strobe meters currently range in price from well under $100 for the Wein meter, to over $250 for such marvelous, state-of-the-art meters like the Minolta, which comes complete with a mind-boggling LED readout. The lower-priced meters are adequate for general use, though they are prone to losing calibration and have to be tested fairly often. They also fall somewhat short in terms of reading ambient light. (Ambient light is that light that exists in addition to the flash, such as the nomal room lighting, etc.)

Many of the inexpensive meters and even a few of the more expensive have a problem reading ultrashort flash durations, such as those created by autoflash units and variable-output thyristor units. (A thyristor is a kind of electronic switch.) Nevertheless, such meters serve a function. At their worst, they will put you in the exposure ball park—let's say within one-stop bracketing range, and at best, if tested from time to time, will put you on the button.

The better units feature silicon cells, which respond in milliseconds to even the shortest burst of light. Many of them can also be used as conventional light meters (a few even have input for shutter speed), and will also read the ambient light along with the strobe output, thus taking into account any other light sources affecting the scene (including bright sunlight).

Autoflash

As you know, exposure on the film in a camera is generally controlled by changing the diameter of the lens aperture to vary the volume of entering lights and/or changing the length of time the light strikes the film. With continuous lighting, such as that outdoors or with photolamps, the length of exposure is the shutter speed. In most electronic-flash photography, on the other hand, the effective exposure time is the duration of the tube's flash.

With ordinary nonautomatic electronic flashguns, the flash

duration is fixed, usually at 1/1000 or 1/2000 sec. Suitable exposure has to be calculated from the flash-to-subject distance for the film in use. Then the resulting lens aperture must be set on the camera before shooting.

An autoflash unit automatically varies the flash duration with no calculations and without changing apertures. With autoflash, a switch in the camera shutter triggers the flash, and its light falling on the subject is reflected back to an electronic sensor which is connected to cut off flash-tube light the instant correct exposure has been achieved.

The two kinds of autoflash may be called the "quench" or "bypass" type and the "cutoff" or "energy-saving" type. Initial cost of the former is less. The energy-saving type, however, can give many more flashes per battery and considerably shorter recycling times for those who need or want these features.

As explained earlier, each autoflash unit contains a kind of storage tank called a capacitor that is charged full before the flash is triggered. The difference between the two types of autoflash is that the "bypass" system diverts the power remaining in the flashgun's capacitor when correct exposure is reached and uses it up in a "quench tube," while the "cutoff" type simply opens the circuit and leaves unused power in the capacitor to speed refilling it for the next use. You may also hear energy-saving autoflash referred to as the "series-thyristor" type, since it uses a thyristor connected in series with the flash tube to do its work. The "series" part is important, since some conventional "quench" units also contain thyristors, but it takes one connected in series with the flash tube to save power. Many units vary flash duration from 1/600 sec. for subjects farthest from the flash to an incredible 1/40,000 sec. for very near subjects. The high speeds of any of these units not only enable automatic close-range flash, but also can be used to make striking shots of "frozen" action.

Many autoflash units offer the photographer an option of *f*/stops, in order to allow variation in depth of field. This variation is compensated for automatically by the flash.

All is not milk and honey, however. The light sensor on an

autoflash is similar in function to that of a reflected light meter and therefore suffers from the same shortcomings. Autoflash, like any reflected meter, reads what is in front of it and makes the usual assumption that it is dealing with an 18% reflectance. Therefore, when used on anything other than an average scene, underexposure or overexposure is a possibility. Care must be taken with subjects against white or black backgrounds and with subjects that deviate too far from an average, 40% gray tone. Despite the fact that the autoflash sensor ranges from about a 25° acceptance angle to about 15°, which puts it in the semi-spot category, in some situations the aiming point of the sensor can be quite critical. If, for example, you are shooting a figure against a black background from about 15 feet or so, and the sensor is not pointed accurately, it is likely to read a good deal of the black area, resulting in overexposure.

I suggest that, though autoflash is a boon to flash photography, like all such devices that attempt to do your thinking for you, it is not to be trusted implicitly. In addition to using *its* brain, you should also use your own. Either compensate for special circumstances, or use the autoflash on manual in all but *average* circumstances. Many of the problems that beset autoexposure cameras also apply here. If in doubt, reread those portions of this book that deal with reflected-light meters and autoexposure cameras.

Fortunately, all autoflash units provide a manual mode with which they can be used as conventional strobes. At least one unit, the superb Sun Pack 511, provides a third alternative, whereby infinitely variable output can be dialed. The flash output can be controlled from ½ power to 1/64 power, taking advantage of its built-in, energy-saving thyristor circuitry. On 1/8 power, this unit will cycle fast enough to sync with a motor drive at three shots per second! It also possesses one of the most accurate calculator dials in the business—which even calculates for its variable output feature.



Bounce Flash

Bounce flash is the answer to many problems. When bounced off a reasonably white ceiling, even a medium-sized portable flash can light a huge area. One very important aspect of bounce flash is that the resultant light does not *look* like flash. In many cases, its sole accomplishment might be to fill the gaps left by the ambient light, imparting an "available-light" look to the photograph.

Through the use of a ball-and-socket attachment, some flash units can be mounted on the camera and pointed upward. Other units supply their own tilting brackets. Beware, however, of strobes with tilting heads that tilt upward less than 90°, with a subject distance of less than 7 to 10 feet. These units are apt to supply only top light, resulting in some bad eye shadows and ugly lighting. Under certain circumstances, the flash can be removed from the camera and aimed by hand, or by an assistant. The light can even be mounted on a light stand with a clamp or stand-bracket. When this is done, a sync-cord extension is needed. Such extension cords are available from photo dealers and will enable some flash units to be fired from as far as 30 feet from the camera.*

For various effects, light can be bounced into corners, or even against walls. *Experiment!*

Exposure can be calculated in the following manner: With normal ceiling heights of approximately 7½ to 9 feet, add two stops to what the comparable direct exposure would be. In other words, if the subject-to-flash distance calls for $f/8$ with direct flash, then bouncing would require approximately $f/4$. With ceiling heights of from 10 to 12 feet, add three stops to the direct exposure. These are not precise calculations, an impossibility due to all the variables involved (size of room, wall color, etc.), so I suggest that until the beginner accumulates experience, he

* Some units have triggering circuits that will not permit this long an extension, but most will easily accept a 10-foot extension.

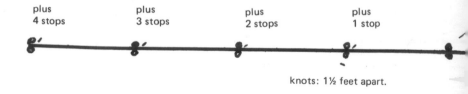

plus	plus	plus	plus
4 stops	3 stops	2 stops	1 stop

knots: 1½ feet apart.

bracket his bounce exposures a full stop in either direction. After a while this can be reduced to a half-stop bracket—and then, someday, instinct will take over and bracketing under these circumstances will no longer be necessary.

Bounce strobe, like bounce incandescent light, produces a soft light that to a large extent requires no fill for the shadows. It can also fill a large area with light that displays surprisingly little falloff.

Bounce light can also be controlled. For example, if you are within 7 or 8 feet of your subject, point the light slightly backward to prevent ugly shadows. Also try pointing your light upward and to the side in order to create soft modeling effects. This works quite well on portraits and nudes.

Do not bounce autoflash, as the sensor will read the light falling on the ceiling, rather than the light falling on the subject. The exception to this is the use of autoflash units with separate accessory sensors that can be pointed at the subject independently of the unit itself. Units with these features are manufactured by Honeywell, Minolta, Vivitar, and others. For all practical purposes, a unit of less than 2000 BCPS is inadequate for ceiling bounce with color film. For black and white, 1400 BCPS is minimum.

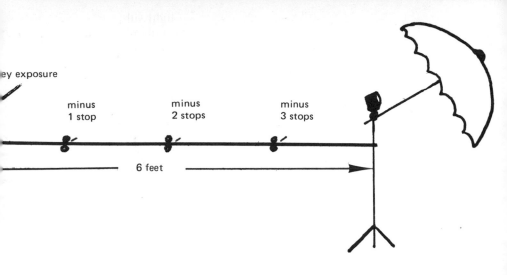

key exposure

minus
1 stop

minus
2 stops

minus
3 stops

6 feet

Umbrella Flash

A strobe can be bounced into an umbrella in much the same
way, and with the same effect as that produced by an incan-
descent light. All that is required is a bracket to attach the strobe
itself to the top of the light stand and a sync extension to connect
it to the camera. That leaves two problems: exposure calculation
and a way of determining where the light is going.

Let's deal with exposure first. The most foolproof way of de-
termining flash-umbrella exposure is first to make a series of tests,
similar to that described earlier relative to determining the key
exposure for direct flash. Mount the umbrella and the flash on
a light stand, making sure that the flash is pointed into the apex
of the umbrella. Place your test subject exactly 6 feet from the
light stand, and with the umbrella about 1 to 2 feet higher than
the subject, and tilted downward, make a series of exposure
tests, on Kodachome 64, running the gamut from $f/11$ to $f/2.8$,
in half-stop increments. As in the previous test, include in each
picture a sheet of paper on which is printed the $f/stop$ being
used. Check the results, pick out the most pleasing, and make
note of the corresponding $f/stop$. Next, cut a piece of string 12
feet long and attach it to the light stand at the junction of the
umbrella. Tie a large knot in the string at the 6-foot mark. This

represents your newfound key exposure. (Determined by the above test.) The purpose, of course, is obvious; the string has become a measuring rod. Make additional knots as shown in the diagram.

It is now a simple matter to measure light-subject distance using the knotted string. Where the distance falls in between two knots, use a half-stop exposure. The key exposure is calibrated for ASA-64, and it is a simple matter of arithmetic to recalibrate it for any other ASA-index you desire. To make things even easier, pin a chart to the umbrella, indexing all eight knots and their corresponding f/stops at the various ASA ratings you will be using. Make sure that the string is permanently attached to the light stand or the end of the umbrella shaft, so that it is ready and available whenever you need it.

In order to see where your umbrella light is going, and approximately what it is doing, mount a 25- or 40-watt bulb in an alligator clamp, inside the umbrella. It will serve as an efficient guide lamp.

For color, a strobe unit of at least 1400 BCPS is required. For black and white, 1000 BCPS is the minimum.

Minimal Flash

There are times when, instead of maximum power, minimum power is required from an electronic flash. These situations can occur when

1. It is desirable to retain the lighting "flavor" of a specific scene, and all that is needed is some means of filling the shadows and making things even out a bit. In this case, the strobe is simply augmenting the main light source, which might be room light or some other ambient source. This can be accomplished by bouncing or using direct flash.

2. You might require minimal light in order to retain a shallow depth of field.

3. You want interesting effects involving action: a slow shutter speed to blur the action and simultaneously a strobe exposure to freeze it. The strobe output, of course, will have to match the f/stop being used for the ambient light. This sometimes might require a minimal output. (For an interesting experiment in this regard, try placing a colored gel over the strobe.)

There are a few ways to reduce the power output from an electronic flash:

1. Use neutral-density filters in either gelatin or acetate. They can be attached by using a thin rubber band over the strobe head.
2. Cleansing tissues, when placed over the strobe head, have an index of roughly two stops. For a one-stop decrease, the two-ply tissue can be stripped. Any number of layers can be used and rubber-banded to the strobe head.
3. You can use your fingers. This takes practice, but after a while you can learn to "play" your strobe like Mulligan plays his baritone.
4. Buy yourself a variable output unit such as the previously mentioned Sun Pack 511.

Synchro Sunlight

When the sun casts ugly shadows on faces, figures, or what have you, the shadows can be filled with flash. This is somewhat easier to do if your camera syncs at 1/125 sec. rather than 1/60, but anything is possible if you put your mind to it. First, determine the sunlit highlight exposure. This exposure should correspond to your sync speed. This means that if your sync speed is 1/60 sec., your meter calibration should be for that shutter speed. Next figure out how far your strobe has to be from the subject in order to equal one-half the ambient highlight reading. For example, if your meter told you that the ambient highlight reading is f/11 at 125 sec. (your sync speed), then you want your

strobe exposure to be $f/8$, or one-half the ambient reading. This will give you a lighting ratio of 2 to 1—your shadow areas one-half the density of your highlights, a nice ratio.

If by some chance (unlikely) your strobe output exceeds this ratio, then it is a simple matter to go to a slower shutter speed, calling for a smaller aperture and a new flash–f/stop ratio, or you can cut strobe output by one of the above methods. When you have arrived at the proper exposure and ratio, stop down a half stop to allow for increased highlights, due to the flash.

Filters

Filters can be placed over the strobe head, for either effect or expediency. As mentioned earlier, a thin rubber band and acetate or gelatin filters are all that's necessary. If, for example, you are shooting in a situation with a high tungsten ambient light source, that is going to register on the film, you will want to use Type B film, rather than daylight film for which strobe is balanced. It becomes a simple matter to attach an 85B conversion filter over the strobe head. This will convert the strobe output from 5500°K to 3200°K (or close enough) so that your strobe output will match both the film and the ambient light in terms of color balance. If you find your strobe output too "cold" (blue), try using an 81B on the camera lens.

Multiple Flash

It is often desirable to use more than one electronic-flash unit to make a picture. There is no limit to the number, actually, although three should suffice for most situations. Multiple flash can be used for *direct* lighting setups similar to those described in Chapter 15, "Shooting in Incandescent Light"—key light, fill light, and backlight, the classic portrait set-up. Multiple flash can also be used to light large areas, such as interiors or exteriors at night. It can also be used to supply the prime light for indoor

sporting events. Multiple flash can be used in conjunction with bounce lighting, with two or more lights, each filling a portion of a large area.

To trigger more than one light, *slave cells* are required. These are small photoelectric cells with built-in triggering circuits, which are activated by other strobes in the area. The camera sets off the initial strobe, and this in turn keys all the other strobes, through the use of photoelectric cells. Slave sensitivity can extend as far as 40 to 50 feet from the camera light. Slave cells are available at your local camera store and are an absolute must whenever more than one strobe is to be used.

Glossary

GLOSSARY

ACUTANCE—The ability of a film or optical device to delineate edge sharpness.

ADDITIVE COLORS—Primaries: red-blue-green.

APERTURE—The lens opening, or diaphragm. See f/stop.

ASA—This term followed by a number indicates the standard rating applied to the light sensitivity of a given film. The ASA refers to the now nonexistent American Standards Association.

AUTODIAPHRAGM—A diaphragm that operates automatically by stopping down to a preselected aperture when the shutter is released. Found on SLR cameras.

AUTOEXPOSURE OVERRIDE—A control whereby the indicated exposure on autocameras may be modified.

BCPS—Beam-candlepower-seconds, a means of measuring the light output of electronic flash units.

BSI—Film speed rating established by the British Standard Institute.

BTL METER—Behind-the-lens exposure meter, found on most SLR cameras and Leica M5 and CL rangefinder cameras. SLR cameras situate the meter cell either within the pentaprism, behind a partially silvered portion of the mirror, or elsewhere in the viewing system. The Leica rangefinder cameras situate the cell directly in front of the film plane on a hinged arm that moves out of the way before the shutter opens.

COCK—The process of readying the shutter for the next exposure, after one exposure has been made and the film has been wound.

CONTRAST—The differentiation in tone or density between a highlight area and a shadow area. The number of steps of gray that separate the darkest and lightest portions of any photograph. When contrast is high, there are fewer such "steps" between white and black than when contrast is "normal."

DEPTH OF FIELD—The distance both in front of and behind the point of focus (on the subject) that remains relatively sharp.

DIAPHRAGM—A device in the lens that contracts much like the pupil of the eye, in order to restrict the amount of light passing through the lens. Also called the aperture.

E.I.—Exposure index, a nonstandard rating that deviates from the standard ASA rating when applied to a given film. (If a film rated at ASA-125 is "pushed" one stop it becomes E.I. 250.)

ELECTRONIC FLASH—A source of light making use of a capacitor which when charged and then released fires a flash tube, resulting in a brief but powerful burst of light. Such tubes may be fired thousands of times before requiring replacement.

EXPOSURE—The combination of f/stop and shutter speed required to expose the film to the correct amount of light, relative to film speed and subject lighting.

EXPOSURE INDEX—*See* E.I.

EXPOSURE METER—A tool used to measure the amount of light falling on a built-in photoelectric cell. A calculator dial, which is an inherent part of the meter, determines the exposure, relative to the amount of light, the film speed rating, and other factors.

FILL LIGHT—A light used to "fill" shadow areas in order that they may reveal some detail.

FILM COUNTER—A device on the camera that indicates the number of frames (photographs) remaining on the film roll.

FILM PLANE—The area within the camera body in which the film, tensioned by a pressure plate, forms a precise plane at right

angles to the axis of the lens. The positioning of the film plane is very critical, as it constitutes the point, or plane, at which the lens focuses.

FILM SPEED—A film's degree of sensitivity to light indicated by its ASA or E.I. rating.

FILTER—A glass, acetate, or gelatin through which light is modified both in intensity and color. Filters are usually attached to the front of lenses. They can also be used to modify light sources.

FLASHBULBS—Oneshot bulbs.

FOCAL POINT—When applied to lenses, the distance from the optical center of the lens to the film plane.

FOCAL PLANE—The plane at the focal length of the lens perpendicular to the axis of the lens. *See* Film Plane.

FOCAL-PLANE SHUTTER—A shutter that is built into the camera body and passes just in front of the film, or focal plane. *See* Shutter.

FOCUS—A means of extending or retracting the focusing elements of a lens so that its distance from the film plane is relative to subject distance. When focused at infinity, the focusing elements are closest to the film or focal plane of the camera; closer distances require greater extensions in order to bring the image into focus on the film.

FOOTCANDLES—One footcandle is the basic unit for measuring light output.

FRESNEL SCREEN—A screen found in most SLR viewfinders, consisting of concentric lines and calculated to spread the viewing light evenly across the face of the ground glass.

F/STOP—Calculated by dividing the optical diameter of the lens aperture into the lens focal length. Thus a lens with a maximum aperture equal to its focal length would be $f/1$. *See* Stop.

GRAIN—Visible clumps of silver in a photograph. Many photographers find grain objectionable. Some few, however, don't.

GUIDE NUMBERS—A factor in a formula for determining flash exposure. The guide number relates to the BCPS of a given elec-

tronic flash and its relationship to a specific ASA rating. Exposure is determined by dividing the distance from flash to subject into the guide number.

HOT SHOE—A bracket atop a camera into which a flashgun or electronic flash unit may be inserted and which contains electric circuitry making the use of a PC cord unnecessary.

IMAGE SIZE—The actual size of a given image on the film. For example, if you photograph an object 1 inch long and its linear measurement on the film is also 1 inch, the image size is said to be 1 to 1 with the subject. At a given distance, a telephoto lens will produce a larger image size than will a wide-angle lens.

INCIDENT LIGHT—Light that is *falling onto* the subject.

INFINITY—Expressed thusly: ∞ . A point of focus beyond which everything will be sharply focused. On most lenses, the infinity setting is reached by turning the focusing ring clockwise till it reaches its maximum position.

INTERCHANGEABLE LENSES—Lenses of varying focal lengths (and other properties) that can be interchanged on specific camera bodies through the use of bayonet or screw mounts.

IRIS—Part of the diaphragm. *See* Diaphragm.

KELVIN TEMPERATURE—A means used to measure the degree to which white light is biased toward the short or long wave end of the visible spectrum. High Kelvin temperature (expressed as "K°") denotes light that is "cold," or balanced toward the blue. Low Kelvin temperature denotes light that is warm or balanced toward red.

KEY LIGHT—The main light in any lighting setup using direct sources of light.

LED—Light-emitting diode, similar to that found on a hand calculator or digital watch. In cameras they are sometimes used for exposure readout or indication.

LENS ABERRATION—Lens design and manufacturing are as prone to distortion and malfunction as is the human eye. The following is a sampling of such "diseases" to which all lenses are

subject to some degree or other. *Central-color fringing:* image unsharpness and color fringing at point of focus. *Central-spherical aberration:* focus shift and flare. *Edge-lateral-color fringing:* Image unsharpness and often multiple-colored images. *Edge astigmatism:* image streaking. *Edge coma:* results in flare (general fog causing unsharpness). *Optical decentering:* a malfunction in manufacturing having nothing to do with lens design. Inexpensive, off-brand lenses are more often guilty of this misdemeanor then are lenses manufactured under strict quality controls. Optical decentering can cause many different types of aberrations. *Residual ghost and flare:* caused by internal reflections within the lens. Can be controlled by lens coating and efficient lens hoods. *Linear distortion:* vertical and horizontal lines forming a pincushion or barrel shape.

LENS ELEMENT—A single piece of optical glass, ground convex or concave (or a complex combination of the two). A modern lens may be made up of as few as two such elements or as many as twenty.

LENS FORMULA—The results of a series of complex calculations made by lens designers to arrive at optimum compromise between lens efficiency and lens aberration. Today's lens formulas are so complicated that they are generally arrived at through the use of computers.

LONG FOCAL LENGTH—*See* Telephoto.

LOUPE—A small magnifying glass of the kind used by jewelers.

LUX UNITS OF ILLUMINATION—A means of measuring incident light. To find the lux value, multiply footcandles by 10.76.

MAXIMUM APERTURE—The widest aperture of a given lens. Sometimes referred to as *lens speed*.

MAXIMUM DENSITY—The blackest area (least exposed) of a color transparency. When "D-max" is low (lacks density), the transparency will suffer from a lack of contrast and a color distortion in the shadow areas.

MOTOR DRIVE—An electrical device used to wind the film and release the shutter. Electric motor drives can be used to

expose one frame of film at a time or, by holding down the motor button, expose as many as four or more frames a second. They are generally sold as accessories, with few exceptions, such as the Minolta XM-Mot, which has its motor and special circuitry built into the camera body itself.

NORMAL LENS—A lens producing perspective close to that of the human eye. In 35mm photography such lenses are roughly 50mm in focal length.

OPENING UP—Increasing exposure by using a large f/stop.

ORTHOCHROMATIC FILM—A black and white film insensitive to red. Currently used for special purposes such as copying, etc.

PANCHROMATIC FILM—Black and white film that is sensitive to red, green, and blue light.

PARALLAX—The divergence in viewpoint between the field of view of a lens and a separate viewfinder such as those found on rangefinder cameras.

PC CORD—The electrical wire that connects a flashgun or electronic flash unit to the camera's synchronization outlet.

PC OUTLET—The electrical connection on a flashgun, electronic flash unit, or camera connected to a PC cord.

PENTAPRISM—Part of the viewing system of SLR cameras. The pentaprism erects the image and corrects it from right to left, while at the same time diverting the image-bearing light 90° from its vertical travel to the horizontal, so that it may be projected through the viewing lens into the eye of the photographer.

PERSPECTIVE—The apparent depth of a photograph relative to near and far objects. When far objects seem larger relative to near objects, perspective is thought of as being *flat*. When far objects appear smaller relative to near objects, perspective is thought of as being long or distorted.

PHOTOELECTRIC CELL—A light-sensitive device that reacts to the amount of light falling on it, either by generating a small current or modulating a current passed through it.

PHOTOSPHERE—Light receptor of an exposure meter.

PUSHING—A term applied to increasing the light sensitivity of a film by increasing its development time.

RANGEFINDER—An optical-mechanical device used to determine distance through the use of two points of view, one being at right angles to the camera-photographer, the other having a variable angle. Modern rangefinders are coupled to the focusing mechanism of the camera itself.

RAPID WINDER—A device similar to a motor drive except that it will not operate on a continuous basis, but winds the film automatically one exposure forward each time the shutter button is depressed.

REFLECTED LIGHT—Light that is *reflected back* from the subject.

RESOLVING POWER—The ability of a lens to resolve small objects or lines. *See* Sharpness.

SELF-TIMER—A means to delay the functioning of the shutter release.

SHARPNESS—The degree to which film, film-processing combinations, and lenses can resolve small details of the subject. Lenses, for example, may be manufactured from inferior optical formulas which cause lack of sharpness. Other causes are camera movement while the shutter is open, flare (internal light reflections within lens or camera body), or dirty lens surfaces.

SHUTTER—A device used to control the duration of time during which the film is exposed to image-bearing light.

SHUTTER SPEED—The duration of time during which the shutter is open, thus allowing light to strike the film.

SLR—Single-lens reflex. A camera, which through the expediency of a hinged mirror, uses a single lens for focusing-viewing and film exposure.

SPEED—The widest aperture of a given lens. *See* Maximum Aperture and Shutter Speed. Also a film's degree of sensitivity to light. *See* Film Speed.

SPLIT-IMAGE RANGEFINDER SPOT—Found in some SLR

viewing screens. The split image acts as a kind of rangefinder with use usually limited to the shorter focal-length lenses.

SPOT METER—An exposure meter that "reads" a narrow angle. Some spot meters, for instance, read angles as narrow as 1°.

STOP—Usually referred to as f/stop. Each "stop" admits 100% more light than the next smaller one. A stop can also refer to any doubling or halving of shutter speed. For example, one might decrease exposure by two stops.

STOPPING DOWN—Using a smaller aperture or f/stop.

STROBE—A rapidly repeating electronic flash. This term is also used synonymously with electronic flash.

SUBTRACTIVE COLORS—Magenta, yellow, cyan.

TELEPHOTO—A lens similar in function to a long-focal-length lens (35mm cameras). It tends to flatten perspective and magnifies image size.

TLR—Twin-lens reflex. A camera that uses one lens for focusing-viewing and another for film exposure.

WATT-SECONDS—An electrical measurement of the output of electronic flash units.

WIDE ANGLE—A short-focal-length lens, which exaggerates perspective and reduces image size.

ZOOM LENS—A variable-focal-length lens.

A FEW WORDS ON EQUIPMENT BUYING

The purchase of a 35mm camera is much the same in terms of choice as is the purchase of a car. A Ford Pinto will get you there just as quickly as will a Cadillac Eldorado. Furthermore, just as power brakes and power windows and electric door locks, etc. increase the cost of an automobile, so do electronic shutters, removable prism housings, and autoexposure increase the cost of a 35mm camera. Nice things to have, but not entirely necessary to get you where you want to go.

Above all, avoid the trap of equipment-collecting for its own sake. This is a very real disease with many photo-hobbyists. Cameras and other photo gear become toys for them to collect and tinker with.

Generally speaking, the average photo dealer is a professional, an honest person whom you can trust. His situation is pretty cut and dried, as the list-price markup on photographic equipment hovers around 40%, and that represents his horizon. Both he and I, and every pro in the business, know something that you, the reader, may not know; no one, absolutely no one, has to pay list price for a camera in the United States. It is just not required of anyone to pay what is laughingly called the "manufacturer's suggested retail price." Of course, if you want to take the manufacturer's "suggestion," I'm sure that your dealer will be happy to accommodate you. However, I suggest you deal on the basis of

a 15% discount. More than that would be greedy (unless you are a very good customer, and then 20% is tops). Your dealer has to live also, and with his overhead, a 20% to 30% markup is fair.

Avoid as if they were plague-ridden the many "going out of business" shops of the kind that currently line the main streets of many major cities. They sell everything from Turkish rugs to TV sets. I have great admiration for the owners of these establishments, as they demonstrate great artistry at bilking the public, and I just can't knock talent of any kind. Nevertheless, beware. What you see in their window displays is not always what you walk home with.

In recent years, mail-order outfits advertising in the popular photo magazines have been offering "combo" sales consisting of a name-brand camera, one or two additional lenses, and possibly an electronic flash unit thrown in. The prices look good—but in many cases the additional lenses are not specified as to brand name. Usually, they are inferior pieces of glass not worthy to be called lenses. My advice is not to buy anything unless you know exactly what it is.

A word also about the guy who approaches you with a $750 Nikon F2 which he has to sell for a lousy two hundred bucks because his mother is in the hospital and needs an operation. At best the Nikon "fell off a truck"; at worst it is the product of a mugging. Now despite the moral consideration, which I trust you've already considered, the chances are good that this camera has been *reported* stolen. If it weren't, the dutiful son would have probably hocked it. He daren't. Pawnshops in most states are required by law to report regularly to the police the serial numbers of all cameras taken in pawn. Since the pawner is required to present identification, it becomes an easy matter to trace the thief. But let's go on the assumption that the guy convinces you and you tumble to the mother story. Six months or a year later, you're going to be somewhat put out when you go to pick up your camera at the repair shop and find that an insurance company has

claimed it! Reputable repair shops refer, regularly, to insurance company lists of stolen cameras.

The best bet is to establish a relationship with a dealer. The smaller photo dealer is best in this department, because he has the time to spend with you. His prices may be somewhat higher than his giant competitor who deals in larger volume, but if he is typical, the small businesman will generally make up the difference with service. If you are going to be involved with photography on a serious level, your annual equipment and supply bill will probably run to four figures. If this is the case, a friendly dealer, who knows you by your first name and who takes an interest in his customers and what he sells them, will be worth more to you than the few bucks you might save. A good dealer, with whom you have established a friendly relationship, will, if he is typical, place special orders for you, rent you equipment, warn you away from inferior merchandise, permit you to try out used equipment before he sells it to you, and even introduce you to other customers with similar interests. In short, the independent photo dealer can be a pleasant fellow to do business with, and this has some value these days, when price competition is cut throat and friendly service is becoming a dim fact of history.

Appendix

Camera's plus accessories selected to suit particular photographic purposes

SUGGESTED SYSTEMS

*Lenses to nearest available focal length.
**For mercury vapor lights found in many arenas.

Specialization	Cameras	Lenses	Accessories	To Upgrade
General Photography	1 SLR body	50mm* 35mm 105mm*	Small electronic flash unit FILTERS #8 Yellow—1 Skylight—1A FLD Tripod Cable-release.	LENSES 24mm* 200mm Incident-light meter FILTERS Polarizer #56 Light green Haze 81-B
General Photography—2 (alternative)	Leica M-5 (M-2, M-3, M-4)	50mm 35mm (Use with finder on M-3.) 90mm	Same as above (If M-2, M-3, M-4: include combination incident-reflected light meter.)	LENSES 28mm Elmarit f/2.8 (with finder) 135mm Elmarit f/2.8 or Tele-Elmarit (Not for use on M-2) Incident-light meter (M-5) FILTERS Same as above.
Nature, Landscapes Architectural	1 SLR body	50mm macro 100mm* short mount lens 28mm	Automatic, coupled bellows for use with short-mount lens. Incident-light mtr. Tripod and cable release. FILTERS #8 Yellow #56 Light Green Polarizer Skylight 1A Haze #2A Small electronic flash	LENSES 35mm perspective correction lens.* (If available in proper mount.) 200mm 21mm* (or 17mm non-fisheye)* 2nd small electronic flash with slave. FILTERS 25A—Red 87—Infra red 61—Dark green 47—Dark blue 81B 82B Sky control filter.